S0-BYW-877

Angels in the ARCHITECTURE

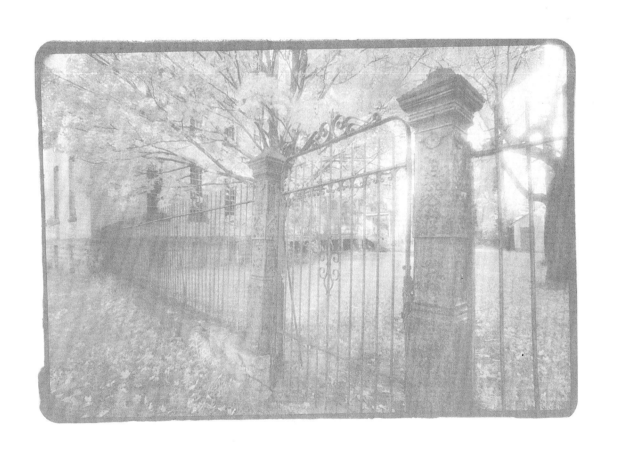

Angels in the ARCHITECTURE

A PHOTOGRAPHIC ELEGY TO AN AMERICAN ASYLUM

HEIDI JOHNSON

Wayne State University Press *Detroit*

GREAT LAKES BOOKS

A complete listing of the books in this series
can be found online at wsupress.wayne.edu

Charles K. Hyde, Editor
Wayne State University

Copyright © 2001 by Heidi Johnson. All rights are reserved. No part of this book my be reproduced
without formal permission. Paperback edition published 2004. Manufactured in Canada.

17 16 15 14 13 7 6 5 4 3

Library of Congress Cataloging in-Publication Data
Johnson, Heidi.
Angels in the architecture: A photographic elegy to an American Asylum / Heidi Johnson.
p. cm. — (Great Lakes books)
ISBN 0-8143-2950-0 (cloth : alk paper)
ISBN 0-8143-3212-9 (pbk : alk paper)
1. Asylums—Michigan—Traverse City—History. 2. Psychiatric hospitals—Michigan—Traverse City—History.
3. Hospital architecture—Michigan—Traverse City—History—Pictorial works. 4. Asylums—Michigan—Traverse City—History—
Pictorial works. 5. Psychiatric hospitals—Michigan—Traverse City—Design and construction—History—Pictorial works.
I. Title. II. Series. RC445.M5 .T698 2001
362.2'1'0977464—dc21
00-011798
ISBN-13: 978-0-8143-3212-2 (paper) ISBN-10: 0-8143-3212-9 (paper)
Grateful acknowledgment is made to Furthermore, a program of the J. M. Kaplan Fund
and to the Committee to Preserve Building 50 for the generous support of the publication of this volume.

All patient names that appear in this publication have been changed, with the exception of artist Virgil Hendges.
In addition, all of the statistical and patient information that appears in this book has been drawn from official state and/or county records.
Wherever possible, all information has been cross-referenced for maximum accuracy.

Dedicated to those who endured . . .
and continue to endure the misunderstood disease of mental illness

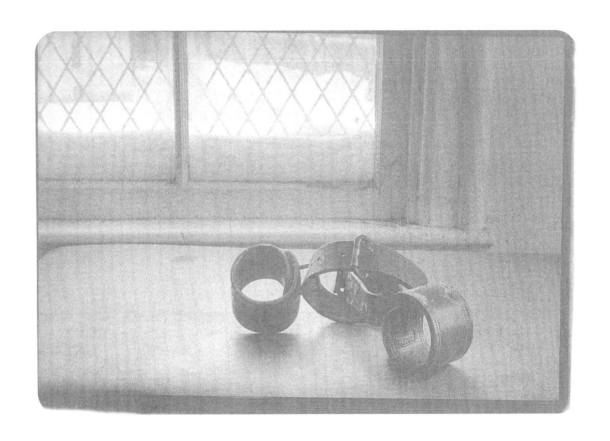

Contents

ACKNOWLEDGMENTS *ix*

PREFACE *xi*

INTRODUCTION BY NANCY TOMES *1*

HISTORICAL OVERVIEW *19*

ANGELS IN THE ARCHITECTURE *27*

AFTERWORD *189*

SOURCES *191*

Acknowledgments

Many people helped me in both large and small ways to produce this book. Several quiet, nearly invisible contributions, so powerful in their sincerity, many times gave me the courage to continue when roadblocks appeared. I especially remember a brief encounter I had with a tearful, trembling woman at one of the rare public tours of Building 50 in the summer of 1998. After pleading with me to tell her if her aunt, a former patient, had been given electroshock treatments during her stay there—a question I could not answer—she purchased a print of mine titled "Radiator Detail" on the small chance that her aunt may have once touched the radiator's surface. I also remember the soft voice of a former patient who told me with simultaneous strength and shame of her experiences within the institution. To the vulnerable souls and the many others who shared your personal stories with me, there are not enough adequate words to describe your effect on me or my gratitude. You are former patients "Jo-Lynn," "Charlotte," and "Elizabeth"; and former Traverse City State Hospital nurses Donna Garn Pillars, Ruth Garn, and Bonnie Witkop Hajek. To Mrs. Margaret Sheets Wolf, daughter of former superintendent R. P. Sheets, thank you for sharing your rare firsthand experiences of life in "Old Center" during the 1930s and 1940s. And to Earle Steele, former head gardener and State Hospital Museum curator, thank you for lending your fifty-plus years of knowledge to this book, and thank you for being one of the first champions for the preservation of this powerful place.

To Nancy Tomes, professor of history at SUNY, Stony Brook, and author of *The Art of Asylum-Keeping*, thank you for sharing your extensive knowledge of the little-known history of moral treatments and Thomas Story Kirkbride.

It took considerable time to locate and document the rare photographs that appear in this book. Several people were invaluable in this process, including Judy Morrell in the Records Department of the Michigan Department of Community Health; Steve Harold and Bob Wilhelm of the Grand Traverse Pioneer and Historical Society; Ann Hoopfer and Dea Talantis of the Con Foster Museum in Traverse City, Michigan; the staff of the Michigan State

Archives; and the staff of the Traverse Area District Library. Other contributors include Julius Petertyl, Mary Rockwood, Shirley Pillars Becker, Viann Markham, Ursula Johnson, Kermit Simon, Riley Billington, Sandy Martis, Jim Olson, and the staff of the Oakwood Cemetery in Traverse City, Michigan. To former Traverse City State Hospital maintenance employees Walter Griggs, Del Wilson, Ralph Reamer, and Hazen Gregory, thank you for your time, patience, and knowledge.

In the moral support department, a heartfelt thanks to Jane Hoehner at Wayne State University Press; my friends from the Committee to Preserve Building 50; Marly Wyckoff, Erin Zoulek, Dianne Foster, David and Beth Pennington, Nikki Darrow, and Suzanne Kramer. And a loving thank-you to my wonderful family: my father, Dennis; my mother, Carolyn; and my sister, Gretchen.

IN MEMORIAM

Donna Garn Pillars, R.N.

Dr. James Decker Munson

Dr. Jack Ferguson

Aviator Donovan Rodriguez

Earle E. Steele

Del Wilson

Preface

I began this series of photographs to document and illuminate some of the most significant nineteenth-century architecture still left standing in the state of Michigan. Buildings of this grace, grandeur, and detail will never be built again, and the sense of urgency to preserve them is real. In recent years many structures at this site have been demolished. Demolition of the one-thousand-foot-long Building 50, the Victorian centerpiece of the former asylum, was slated for June 1998 but was temporarily delayed due to community resistance. Building 50 was closed and abandoned by the state of Michigan in the 1970s. In 2002, after thirty years of neglect, the building was saved.

More importantly, these images were created to pay tribute to the angels of this old architecture: the thousands of patients who lived and died here, some truly ill, others only victims of society's ignorance and neglect. One long-term patient, my Aunt Harriet, was just a childhood shadow of a person rarely spoke of, and then only in hushed tones. Sadly, all were victims of a time when knowledge of brain chemistry was minimal, many treatments were experimental, and life-altering medications had not yet been invented. I believe it is time to lift the shroud of shame and stigma that surrounds mental illness and shine light into darkness with hope of germinating compassion instead of fear.

HEIDI JOHNSON

ICE STORM
NORTHERN MICHIGAN ASYLUM,
circa 1890

Courtesy of the
Grand Traverse Pioneer
and Historical Society

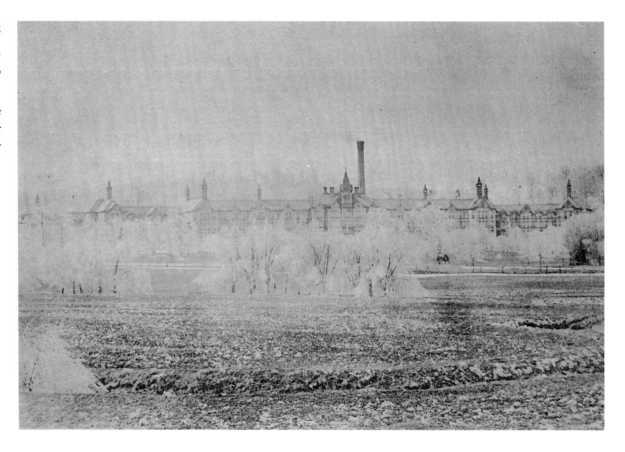

Introduction

Nancy Tomes

THE ASYLUM AS THERAPEUTIC LANDSCAPE

The building and grounds of the Northern Michigan Asylum stand today as mute witness to a therapeutic movement that once flourished in the United States. In the nineteenth century, nearly two hundred mental hospitals were constructed in states across the country, including three that were built in Michigan between 1858 and 1885. The rapid expansion of the mental hospital system signified a belief that specially designed and landscaped buildings could heal one of the most frightening of human ailments. Some of these nineteenth-century structures are still in use, but many more have been abandoned and marked for demolition. Of Michigan's three historic hospitals at Kalamazoo, Pontiac, and Traverse City, only the latter still stands. So sturdily built that the expense of tearing them down is often exorbitant, the old buildings exist as a haunting reminder of a largely forgotten era in American psychiatry.

Since World War II, the mental hospital has been a symbol of good medical intentions gone wrong. Although policymakers concede that mental hospitals have their uses if properly funded and maintained, the belief that the buildings themselves can exercise a healing power has little credibility today. Indeed, for almost a quarter of a century, advocates of deinstitutionalization have successfully argued that it is difficult to get well in a mental hospital, and that people with psychiatric disorders are best treated in the community with as little restraint as possible. Both medical theory and state policy have abandoned the original premise behind the nineteenth-century asylum that a radical break with the outside world and immersion in a tightly ordered institutional milieu could restore sanity. Popular novels and movies such as *The Snake Pit, One Flew Over the Cuckoo's Nest*, and *Frances* have helped equate the image of the mental hospital with ineffective doctors, uncaring nurses, and abusive attendants. Although psychiatric hospitals still play an important role in health care today, they are usually seen as a last resort rather than the cutting edge of medical care.[1]

Still, as anyone who has ever visited a nineteenth-century asylum can attest, these buildings have considerable power to fascinate. By taking the reader on a virtual walking tour of the Northern Michigan Asylum, this volume conveys that power in photographs and words. At one level, the power is visual: from the layout of the hallways to the details of the ironwork, nineteenth-century asylums retain considerable aesthetic appeal because of the care lavished on their design. At another level, the fascination is with the stories conjured by their empty wards. The old photographs reinhabit the crumbling building with images of its inmates and the diverse tragedies and triumphs their lives encompassed.

As a historian who has visited many old mental hospitals, I can attest to the intense emotions—both negative and positive—they can evoke. The American mental hospital was hardly a perfect institution. Even at their best, nineteenth-century asylums had many repressive and unappealing features that made sick people hate to be confined in them. At their worse, asylums lived up to the unsavory reputation that American popular culture bestowed on them. Yet despite its many flaws, the nineteenth-century mental hospital represented a design achievement that was and still is intriguing. At a time when many Americans are becoming interested in the Chinese art of *feng shui*, or natural design, perhaps there are new lessons to be learned from studying the era of grand hospital design. In that spirit, this book replicates the experience that Heidi Johnson and I have had the privilege to enjoy: a close-up look at the building and grounds of a classic nineteenth-century mental hospital.

As a prelude to this virtual tour of the Northern Michigan Asylum, this essay surveys the cultural milieu that gave birth to the asylum idea and the therapeutic landscape it represented. At the center of the account is Thomas Story Kirkbride, whose work profoundly influenced Michigan's first generation of asylum superintendents, including Edward Van Deusen, Henry Hurd, and James Decker Munson. As historians of psychiatry have long recognized, Kirkbride's philosophy of hospital design and landscaping dominated the era of asylum expansion in the United States. As one of the original thirteen founders of the American Psychiatric Association, Kirkbride wrote that association's first official standards for hospital design, which were ratified in 1851 and amended in 1853. His book on asylum design, first published in 1854 and reissued in 1880, was the authority on the subject for more than thirty years. All three of Michigan's historic asylums were built along the lines of the "Kirkbride plan." [2]

Kirkbride's career illustrates both the strengths and weaknesses of the first generation of "asylum superintendents," as psychiatrists were called in his era. A slight, soft-spoken Quaker, Kirkbride was a skilled administrator whose own hospital, the Pennsylvania Hospital for the Insane, achieved an exceptionally high standard of care. A superb clinician, Kirkbride was sought by other asylum superintendents when their own troubles became too much to bear. Yet like so many of the "original thirteen" founders, Kirkbride found it difficult to adapt his asylum philosophy to the political realities of the late 1800s, a time when states were becoming increasingly unwilling to build enough small, expensive mental hospitals to serve the growing number of chronically ill Americans. At a more personal level, his life reflected the complexity of doctor/patient relationships in the nineteenth-century asylum: he was shot in the head by one former patient, sued in a highly publicized case by another, and married yet a third. (Far from being viewed as unethical, this marriage between doctor and former patient was at the time seen as a tribute to the efficacy of moral treatment.)[3]

Perhaps no aspect of Kirkbride's career is more difficult to understand than the extraordinary faith he invested in the healing influence of the hospital building and grounds. Like many of his contemporaries, including Michigan's asylum founders, Kirkbride fervently believed that carefully designed conjunctions of architecture and landscape had tremendous curative powers. As a practitioner of "moral treatment," the dominant therapeutic approach of the mid-1800s, he believed that removal from the outside world and immersion in an ordered regimen held the most promise for curing what had hitherto been considered an incurable disease, namely, mental illness, or insanity, as it was more often called. Nineteenth-century asylum doctors were virtually obsessed with hospital design and management. Many of the early meetings of the Association of Medical Superintendents of American Institutions for the Insane, or AMSAII (now known as the American Psychiatric Association), concerned what historians have termed the asylum's "moral architecture" and "therapeutic landscape." The construction of hospital buildings and the planting of ornamental gardens and parkland around them were seen as integral parts of "moral treatment"—the therapeutic modality that prevailed during the rapid expansion of mental hospitals in the nineteenth century and the historical antecedent of what today is called "milieu treatment" or "milieu management."[4]

Scholars have long been critical of the investment that Kirkbride and his generation, including Michigan's early asylum doctors, made in the hospital's building and grounds. Some historians have argued that the early profession's focus on details concerning window guards and patient "pleasure grounds" reveals their limited therapeutic horizons. By concentrating so much of their energy on such mundane matters—so the argument goes—the founding generation of psychiatrists neglected the "real" practice of mental medicine. John Galt, the dissident head of the Eastern State Lunatic Asylum, summed up this perception of the original thirteen when in 1855 he accused them of wasting time by "tinkering with gas-pipes and studying architecture" rather than treating their patients.[5] Even more sympathetic analysts of moral treatment have tended to assume that nineteenth-century asylum superintendents emphasized gas pipes and greenhouses because the rest of their therapeutic cupboard was sadly bare, so to speak. As of the mid-1800s, the pharmacological measures at their command were few: opium derivatives, morphine, cupping, and purging. Psychoanalysis was many decades in the future. These treatment modalities seem so paltry in comparison to the many therapeutic options psychiatrists have today that it is easy to assume that nineteenth-century doctors focused on buildings and gardens because that was all they had.[6]

Certainly, institutional treatment became an attractive alternative in the nineteenth century because neither drugs nor individual therapy seemed all that efficacious. Moreover, the exclusive identification of psychiatry with mental hospitals led American psychiatrists into an unproductive stalemate by the late nineteenth century. In the ensuing battles over cost versus quality care, psychiatrists lost heavily, and standards in American mental hospitals rapidly declined. Still, the opposition between buildings and grounds and treatment that so often has been invoked to disparage the early practice of asylum medicine is historically misinformed. The treatment modalities of physicians such as Thomas Story Kirkbride and his Michigan counterparts—Edwin Van Deusen, Henry Hurd, and James Decker Munson—were not a poor "second best" but rather a means vested with enormous power to cure. Their interest in hospital architecture and landscaping was far more imaginative than the "second best" interpretation suggests. Only by re-creating the visual and cultural landscapes of the early 1800s can we appreciate their vision of the asylum as an instrument of cure.

Kirkbride and his contemporaries began the practice of psychiatry in a culture that revered certain visual experiences and landscapes as transformative; far from marking them as narrow-minded or isolated, their faith in a

"therapeutic landscape" connected them with the main intellectual currents of mid-nineteenth-century American society. Yet the outlines of this therapeutic landscape are difficult to recapture. Indeed, one of the most perplexing problems in cultural history is to try to recapture the visual and spatial textures of the past. Historians and other scholars attempt to do that by reconstructing the "built environment"—reading what is left of old buildings and plantings, studying old prints, and trying to re-create from those texts the visual impressions they once produced. (Heidi Johnson's book is a splendid example of precisely this kind of work.) Such historical reconstructions allow us to reimagine the asylum as a visual landscape and to identify the cultural assumptions about nature that informed the nineteenth-century art of asylum-keeping.[7]

In order to understand why nineteenth-century psychiatrists invested so much in moral architecture and therapeutic landscapes, we must first appreciate the distinctive "built environment" in which they lived. In the early 1800s, when the mental hospital began to assume its monumental form, buildings of their size were still very rare. The vast majority of Americans lived in rural areas, where even the finest homes had few pretensions to grandeur. When they visited or moved to towns or cities, the vistas they encountered were hardly impressive. The great revolution in city planning that would produce the kind of "grand operatic" vistas, to borrow art historian Barbara Novak's term, found in cities like New York and Chicago had yet to occur. Buildings shorter than three stories, closely packed together with very narrow frontages on the street, were the norm. The grandest public buildings that American cities had to offer in the first quarter of the nineteenth century were still remarkably modest in scale, and the potential of landscape architecture to enhance their dramatic impact was as yet little exploited.[8] Thomas Story Kirkbride and his contemporaries came of age in a culture that was just beginning to appreciate the power that large buildings and skillful landscaping schemes could invoke. Put in the context of their times, the visual impressions of asylum building and grounds that they envisioned and executed were remarkably innovative.

THE PSYCHIATRIST AS NATURE LOVER

Even now, after the environmental movement has heightened appreciation of nature, it is difficult to comprehend the almost mystical influence that nineteenth-century intellectuals and reformers, including asylum doctors, placed on

the psychological and moral influence of nature. In assuming that nature, as imitated and domesticated in the hospital grounds, had great healing powers, Kirkbride and his generation reflected a common set of nineteenth-century ideas. The same decades in which the asylum came of age were the peak of what historian Catherine Albanese has called "nature religion."[9]

Of course the peculiarly American obsession with nature began long before the nineteenth century. The great intellectual historian Perry Miller described the original Puritan settlements in New England as an "errand into the wilderness" and emphasized how European-Americans continued to see themselves as "nature's nation" long afterward. But "nature religion" perhaps reached its peak in the mid–nineteenth century, as Americans made the transition from a rural to an urban way of life and watched their commercial and industrial enterprises transform both familiar landscapes and social customs.[10]

The expansion of the asylum system coincided with American romanticism's celebration of nature. William Cullen Bryant wrote his poems "A Forest Hymn" and "To a Waterfowl" around the time the Friends Asylum—the first hospital built specifically to offer the new moral treatment—opened in Frankford, Pennsylvania. Ralph Waldo Emerson published his famous essay "Nature" in 1836, just a few years before the young Thomas Story Kirkbride took charge of the new Pennsylvania Hospital for the Insane. Henry Wadsworth Longfellow was composing poems about seaweed and the evening star around the time AMSAII held its first meeting. Henry Thoreau penned his *Walden* in 1854, the year Kirkbride published his treatise on asylum design and management; Walt Whitman's *Leaves of Grass* appeared a year later.

During these decades, American painters were also obsessed with recording the "sublime" in nature. The most celebrated works of art produced in this period replicated the glories of the American landscape, even as those landscapes were being destroyed by "progress." The original thirteen practiced during the high point of the Hudson River school, which produced such monumental works as Thomas Cole's *Expulsion from the Garden of Eden*, finished in 1828, Frederick Edwin Church's *Twilight in the Wilderness* (1860), and Albert Bierstadt famous panorama *The Rocky Mountains* (1863).[11]

Nineteenth-century poets, artists, and asylum doctors in this period shared a common set of ideas about the moral and educational uses of nature. In these last decades before Darwin, whose *Origin of Species* appeared in 1859,

it was not "nature red of tooth and claw" they venerated, but a romantic nature of beauty and majesty. Their veneration of nature had deeply religious overtones. As Emerson wrote in 1836, nature is "always the ally of religion: lends all her pomp and riches to the religious sentiment." Through a sacramental relationship, or "communion" with nature, Americans could learn of God's goodness and the moral laws through which He governed His creation.[12]

These same ideas figured in the proliferation of health-reform movements that emerged in nineteenth-century America. As Albanese notes in her study of "nature religion," numerous reform groups and sects emphasized the tie between nature and healing. Health reformers from Sylvester Graham to John Harvey Kellogg preached the gospel of "natural foods"; healing sects such as homeopathy and hydropathy emphasized natural medicines; water cures and spas were touted for their healing natural environments. Although asylum doctors took a more positive view of traditional medicine than many health reformers, they nonetheless shared many of the reform principles of natural healing.[13]

As historian Kenneth Hawkins has shown in his dissertation, "The Therapeutic Landscape: Nature, Architecture, and Mind in Nineteenth-Century America," Kirkbride and his generation worked within an intellectual tradition that emphasized the restorative influence of nature. It was widely believed that external impressions influenced the mind's operations; certain vistas could be elevating, cheering, and tranquilizing, while others were depressing and demoralizing. To understand their conception of nature's healing power, it is important to remember that the term "moral," as used in the nineteenth century, had a different meaning than it has today, a meaning now subsumed by the modern term "psychological." "Moral" meant the opposite of material; it encompassed the mind, emotions, and soul—those things that existed independently of the physical body yet could be influenced by the manipulation of sensory and emotional impressions.[14]

Moral treatment aimed to alleviate the psychological causes of mental disease by radically changing the individual's environment and daily regimen. Assuming a reciprocal connection between mind and body, moral treatment premised that *confinement in the asylum itself* could exercise a direct healing influence on the mind. Given that insanity was characterized by irregularity in mental and physical functioning, its treatment logically should include the imposition of order, harmony, and balance, in terms of both visual stimuli and behavioral patterns. To counteract the overstimulation and stresses of modern life thought to cause mental disease, the sufferer should be removed from the everyday world and immersed in a "new kind of existence," to use Kirkbride's words.[15]

The nineteenth-century asylum literally and stylistically represented a splitting off from the eighteenth-century hospital. Several of the early asylums grew out of general hospitals whose wards for the insane grew so crowded that their boards of trustees decided to found separate institutions for their care. Thus the managers of the Pennsylvania Hospital, established in 1752, opened the Pennsylvania Hospital for the Insane in 1841. The eighteenth-century hospital and the nineteenth-century asylum shared some common style of architecture: regular, classical lines and grounds with gardens. Where the asylum became strikingly different was in its location. As the older urban hospitals became hemmed in by the city, they allowed less of the privacy, space, and quiet thought beneficial for mental patients. The new asylum was carefully constructed to counter the "maddening" aspects of nineteenth-century urban life. Its removal from the city to the "middle landscape," or "borderland" between city and country, promised a landscape that combined elements of rural and urban life. The building was "purpose-built" for the care of the insane and, perhaps most importantly, set within a carefully crafted naturalistic landscape. As part of the daily regimen, patients were surrounded by the healing power of nature—a nature carefully shaped by conscious effort to produce beautiful or picturesque tableaux.[16]

Kirkbride and his fellow superintendents did not invent this treatment approach; rather they refined and elaborated a connection between moral environment and cure inherited from the early-nineteenth-century English asylum movement. In concrete terms, those lines of influence flowed, via the Society of Friends, from the York Retreat in York, England, founded in 1796, to the Friends Asylum in Frankford, Pennsylvania, the first American asylum founded explicitly to practice moral treatment. Drawing on the eighteenth-century tradition of landscape gardening of English country houses, the York Retreat's founders provided for extensive gardens and groves for the patients' enjoyment. Similarly, the founders of the Friends Asylum, which opened in 1817, envisioned a carefully designed building situated in extensive gardens and walkways as an integral aspect of treatment. Its attending physician, Charles Evans, was among the earliest American asylum doctors to elaborate on the therapeutic uses of nature, an influence that undoubtedly impressed Kirkbride during the year he served as a resident at Friends, from 1832 to 1833.[17] Following the same inspiration, other early American asylums such as the MacLean Asylum, Bloomingdale Asylum, and the Hartford Retreat (now the Institute for Living), cultivated the therapeutic influence of their grounds.

At the Pennsylvania Hospital for the Insane, Kirkbride expanded upon and popularized those principles through his writings on asylum design and management. He was particularly skilled in distilling his institutional experience into guidelines and suggestions that other physicians and hospital trustees found useful. In a variety of ways, his practice of moral treatment incorporated images and impressions of nature. The daily asylum regimen included lengthy periods for outdoor exercise, and patients were encouraged to walk outdoors, ride the circular railroad, work in the garden, and see the natural curios in the museum house. Objects of natural beauty were brought inside the asylum: the conservatory supplied flowers for the wards, a practice Kirkbride considered not a frill but a therapeutic measure as important as medical treatment.

Kirkbride's invocation of nature helped to cultivate what he termed a "generous confidence" in his treatment on the part of patients and their families. Families usually committed relatives to the asylum only after exhausting other alternatives, and they came with many negative or ambivalent feelings about their decision. In responding to their needs, the asylum doctor faced a difficult design dilemma. On the one hand, the building had to be safe—patrons counted on him to protect patients from their violent impulses toward themselves or others—but on the other hand, they wanted their loved ones to be comfortable and happy. Encountering an impressive building set in a graceful, well-kept parkland setting helped to soften the effect of the hospital's barred windows and enclosing walls. The ornamentation of the asylum landscape helped distance it from the image of the penitentiary, which developed along similar architectural lines in this period.

Kirkbride's skill in the design and maintenance of an attractive but secure hospital environment contributed immeasurably to the professional reputation he enjoyed. His conceptions of architecture and landscape went hand-in-hand. Kirkbride preferred the so-called linear plan because it provided attractive views from every room and common area and allowed patients direct access to the outdoors without having to walk through long hallways or other wards. In his writings, Kirkbride constantly emphasized that such attention to landscape was not a detail or luxury but rather an integral aspect of treatment. As he wrote in his annual report for 1842: "It should never be forgotten, that every object of interest that is placed in or about a hospital for the insane, that even every tree that buds, or every flower that blooms, may contribute in its small measure to excite a new train of thought, and perhaps be the first step towards bringing back to reason, the morbid wanderings of a disordered mind."[18]

This emphasis on environment as therapeutic modality was passed on from superintendent to superintendent in many ways. At a time when medical schools offered no specialized courses on mental illness, superintendents for new asylums were almost always selected from the ranks of assistant physicians in established hospitals. In Michigan, for example, Van Deusen had worked as an assistant physician at New York State's Utica Hospital; in turn, his assistant physicians, Henry Hurd and James Decker Munson, went on to head the Pontiac Asylum and the Northern Michigan Asylum at Traverse City, respectively. During these asylum "apprenticeships," doctors learned the importance of building maintenance and design. Superintendents and trustees of new hospitals would often supplement their institutional experience by taking an asylum "grand tour." Kirkbride's Pennsylvania Hospital for the Insane was a frequent stop for fledgling superintendents, who went to study its therapeutic "equipment," that is, how the wards were laid out, how the grounds were arranged, and so forth. Doctors often kept journals of their asylum tours to consult on their return home and to share with other superintendents in published form.[19] Early AMSAII meetings, which were often held in a location adjacent to one of the member's institutions, usually included one such inspection tour. After reading and discussing papers at the local hotel or meeting hall, attendees would adjourn to the nearby asylum so that the host-superintendent could "exhibit" his hospital. These visits generated enormous anxiety, for the host doctor's professional standing depended in no small measure on the impression made by his building and grounds during annual meetings and other tours.

Landscaping and building design was not solely the concern of affluent private asylums. The dogged attachment of AMSAII to Kirkbride's principles stemmed from the conviction that the asylum environment was an important therapeutic modality, not a frill meant only for wealthy patients. As Luther Bell put it, "appropriate edifices constitute an apparatus almost as indispensable for the treatment of insanity as any mechanical contrivances in the practice of surgery." Because of chronic funding problems, the improvement of building grounds at the early state hospitals proceeded less rapidly than at private hospitals. But it did proceed, as both superintendents and their boards of lay managers worked hard to convince state legislators that funding for such items was needed.[20]

The extraordinary care lavished on many state hospitals is evident in the construction of the Northern Michigan Asylum at Traverse City. The photographs in this volume illustrate the attention to detail found in such features as ironwork and woodwork. In the tradition of the Kirkbride plan, its wards had many large windows that

provided not only light but also views of the surrounding countryside. As Northern Michigan Asylum's first annual report makes clear, the natural beauty of the asylum site was an important factor in its choice. The trustees wrote that "The location of the institution is fine, and affords a view of the bay and surrounding country that cannot well be surpassed in beauty of outlook. . . . The hills in the rear of the institution, which are heavily wooded, and cut with most charming ravines, are greatly appreciated by our people, and this . . . tends greatly to their benefit as well as to contentment in their asylum home."[21]

Like Kirkbride, James Decker Munson placed great emphasis on the cultivation of the Northern Michigan Asylum's grounds. Although there is little likelihood the two men ever met—Munson became superintendent in 1885, two years after Kirkbride died—they clearly shared a deep commitment to the idea of the therapeutic landscape. From its opening in 1885, Munson lavished enormous care on the asylum grounds. A devoted traveler, he made a hobby of bringing back rare trees and shrubs to add to the asylum "collection." Many of these beautiful plants still surround Building 50. Heidi Johnson's photographs of specimens such as the copper beech and the "sister black willows" show how Munson used plants to realize his conception of the therapeutic landscape.[22]

From Asylum to Park

Not only did the concept of the therapeutic landscape shape the design of the early asylums but it also had a far-reaching impact on another important new institution that arose in the nineteenth century: the public park. As Kenneth Hawkins has shown, the tradition of asylum-landscape design that psychiatrists such as Kirkbride and Munson pioneered was an important inspiration for the leaders of the public parks movement in the mid–nineteenth century, particularly Andrew Jackson Downing and his two talented students, Calvert Vaux and Frederick Law Olmstead.[23]

The rise of moral treatment coincided with a growing awareness of the therapeutic uses of nature not just for mental patients but for all the harried souls living in American cities. Prior to the 1850s, American cities had some green, open spaces, but they lacked the kind of grand public parks that distinguished European cities such as London and Paris. The early parks movement in the United States grew out of a conviction that naturalistic landscapes adjacent to cities could serve as an antidote to the stress of urban life. Its early leaders found inspiration in the new

parklike garden cemeteries founded on the outskirts of large cities during the 1820s and 1830s, such as in Mt. Auburn in Boston, Laurel Hill in Philadelphia, and Greenwood in Brooklyn, New York. They also drew on the asylum tradition represented by Kirkbride and his contemporaries, who used the landscape to provide oases for contemplation and reflection.[24]

The asylum/park connection appears first in the work of A. J. Downing, America's most influential architect and landscape designer of the antebellum period. Downing was influenced by the American tradition of asylum landscaping that Kirkbride and Munson helped to perfect.[25] In 1848, in a complaint about the relative lack of public parks in the United States as compared to Europe, Downing noted that "It is somewhat curious, but not less true, that no country-seats, no parks or pleasure grounds, in America, are laid out with more care, adorned with more taste, filled with more lovely flowers, shrubs and trees, than our principal cemeteries and asylums." Downing praised the principle of asylum landscaping in terms that showed he clearly understood the basic premises of moral treatment: "Many a fine intellect, overtasked and wrecked in the too ardent pursuit of power or wealth, is fondly courted back to reason, and more quiet joys, by the dusky, cool walks of the asylum, where peace and rural beauty do not refuse to dwell."[26]

In the 1840s Downing created landscape plans for two asylums: the New York State Asylum at Utica, where Edwin Van Deusen worked as an assistant physician, and the New Jersey State Asylum at Trenton. Downing's asylum schemes used screens of trees planted in irregular belts to encircle lawns and meadows and give the hospital a sense of privacy. Downing's asylum work probably influenced the most ambitious project he ever undertook: his 1850s plan for landscaping the public grounds of Washington, D.C., one of the earliest large-scale parks in United States. It seems likely that the Smithsonian "pleasure grounds" took some inspiration from the asylum pleasure grounds that Downing had previously designed. Unfortunately, this work was also uncompleted due to Downing's death, which occurred in a steamboat accident in 1852, when he was only thirty-seven.

The asylum/park connection, Hawkins shows, is even more evident in the career of Frederick Law Olmsted, who is perhaps best known for designing New York's Central Park but who also designed parks in Boston, Brooklyn, Buffalo, Louisville, Montreal, and other cities. Like Downing, Olmsted and his partner, Calvert Vaux, did asylum designs throughout the period that they were also designing parks. Their designs for asylum grounds and urban parks

shared a common dependence on screening belts to ensure privacy and on greenswards to provide sweeping vistas. Olmsted's writings on the therapeutic value of parks show a strong sympathy with the traditions espoused by Kirkbride and Munson. In 1865 Olmsted wrote, "The enjoyment of scenery employs the mind without fatigue and yet exercises it, tranquilizes it and yet enlivens it." Even as he became famous for his urban parks, Olmsted continued to design asylums, including the Hudson River State Hospital near Poughkeepsie and the Buffalo State Hospital.[27]

THE PATIENTS' EXPERIENCE OF THE THERAPEUTIC LANDSCAPE

The concept of the "therapeutic landscape" clearly commanded widespread allegiance in nineteenth-century America. Yet the question remains: Did the asylum superintendents' attention to the built environment of the hospital and its grounds have the desired effect on hospital patients and their families? The asylum archives suggest that patients' responses to the asylum varied far more than the founders might have liked. Just as Roy Rosenzweig and Elizabeth Blackmar found in their history of Central Park, users did not always interpret the built environment as its architects intended. This disjuncture between ideology and reality proved a constant source of disruption in the daily life of the institution.[28]

Patients' varied responses influenced the therapeutic landscape from its inception. As Hawkins has noted, patients shaped the therapeutic landscape by making clear their preferences for its recreative rather than labor-intensive uses. Always worried about money, asylum superintendents repeatedly tried to make the therapeutic exercise of patient farmwork pay off in the form of a reduced food bill. But many patients often resisted working on the asylum farm: those who were paying for treatment resented having to work, and once that group was exempted, the rest refused as well. Munson had more success than many asylum superintendents in getting inmates to work. The majority found it easier to emphasize the more passive, recreational aspects of the asylum landscape.[29]

Class, race, and gender differences among patients created other problems in the use of the asylum grounds. Moral treatment assumed that patient "amusements" should be geared to the person's station in life; thus male patients from professional or business backgrounds were rarely recruited to work on the asylum farm. Female patients tended to spend more time indoors, sewing and doing laundry rather than gardening. Racial differences also shaped the use of

the building and grounds. Both Northern and Southern mental hospitals were highly segregated in this period. The Virginian John Galt, the one asylum doctor who expressed the belief that no harm would come from treating white and black patients in the same ward, was roundly criticized by his colleagues. In a not-so-veiled reference to Galt, Kirkbride wrote, "The idea of mixing up all color and classes as seen in one or two institutions in the United States, is not what is wanted in our hospitals for the insane."[30] In hospitals with large numbers of African American inmates, black patients were usually given separate and inferior wings, presumably also with segregated exercise grounds and gardens. The Pennsylvania Hospital archives does contain a handful of references to black patients, but it is unclear where and how they were housed. Similarly, little has been found that indicates whether the Northern Michigan Asylum was segregated.

The mental status of the patients also produced contradictory perceptions of the therapeutic landscape. While some expressed appreciation for the beauty of the building and grounds, others were either indifferent or actively hostile to their surroundings.[31] On the positive side, patients who felt overwhelmed by their problems saw their stay in the asylum as a welcome withdrawal from the maddening world. After leaving the hospital, one woman wrote to Kirkbride that she missed her former retreat, as the noise and the bustle of the city disturbed her. However, some of Kirkbride's charges were in states of such emotional pain or disorientation that they little appreciated the therapeutic landscape around them. For them it was a constant effort to leave their rooms and go outside. As one man wrote, "The associations here are not pleasant, they remind me of my condition when I came here, which I cannot get rid of for the want of something else to occupy my mind." For a few, the asylum grounds became a landscape for defiance. On at least two occasions, patients drowned themselves in the picturesque hospital pond, thus using the beautiful grounds as an opportunity for self-destruction. In 1849 a former patient named Wiley Williams climbed a tree on the hospital grounds and shot Kirkbride as he walked to the wards for his early morning rounds. Luckily the doctor's hat deflected the small caliber shot, so he quickly recovered from the injury. For patients bent on liberty, the asylum parkland became an escape route. Belying the image of a "total institution," male patients escaped from the asylum regularly. Kirkbride's legal bête noire, Ebenezer Haskell, escaped from the hospital several times. He eventually sued the hospital on the grounds of "wrongful confinement" and published an exposé of his mistreatment there, which included a dramatic drawing of himself escaping over the outside wall.[32]

For critics of the asylum, whose numbers began to grow in the post–Civil War period, the very care taken to make hospitals beautiful became suspect. They likened the asylum to a "whited sepulcher," lovely on the outside but rotten inside, due to the abuse and neglect of patients. The author of an anonymous article in the 1868 *Atlantic* titled the "Modern 'Lettre de cachet'"—a reference to the letters that got one sent to the Bastille before the French Revolution—warned that neither well-kept grounds nor "ornamental cast-iron screens" could conceal the loss of liberty taking place behind the "frowning stone edifice" of the mental hospital.[33]

THE THERAPEUTIC LANDSCAPE IN DECLINE

For a variety of reasons, the idea of the therapeutic landscape became increasingly less compelling after the 1880s. Its decline was linked with the decline of moral treatment in general, which suffered from its own internal contradictions: the difficulty of ridding mental illness of its disturbing and irregular elements, especially given the limited drugs available to calm patients; the inevitable decay of the hospital buildings themselves, which proved extremely expensive to properly maintain; and, most importantly, the accumulation of uncured patients. Gerald Grob has estimated that at least one-third to one-half of all mental patients in the nineteenth century were suffering from syphilitic infections or other organic conditions that even the most successful implementation of moral treatment could not have alleviated.

Theories of mental illness that became popular in the late nineteenth century had little use for asylum design. As German neurology and psychiatry gained influence within the American profession, the older emphasis on sensory impressions and mental habits diminished. The new somaticism stressed the hereditary sources of insanity and held out little hope for its cure. In the early 1900s, the growing influence of psychodynamic theories shifted attention to what we might think of as the interior landscape—the interplay of the id, ego, and superego—and to the familial origins of mental illness. Neither the somatic or psychodynamic traditions emphasized the asylum building as a therapeutic tool.

Changes in visual culture also diminished the impression made by the old asylums. As the "grand opera" approach became common to cities and towns, Americans became more accustomed to seeing large buildings and

cultivated landscapes. Meanwhile, cities grew up around many of the old mental hospitals; the borderland turned into city and the rural "retreat" disappeared. Hospital boards strapped for cash sold off tracts of asylum land. Eventually, some asylums, such as New York's Bloomingdale Hospital, moved to newer suburbs, while others, like the Pennsylvania Hospital for the Insane, stayed and became urban institutions. In the end, very few of the old hospitals were able to preserve or replicate their retreat image.

Once set in the middle of a one-hundred-acre farm, Kirkbride's hospital now sits on a few acres of land in a struggling inner-city neighborhood. Surrounded on three sides by small row houses and bordered by an elevated transit line, it is difficult to imagine the visual impression that it once made. Still, the historic asylum, which is now known as the Kirkbride Building, has a grandeur about it that the newer hospital buildings built adjacent to it lack. One sees that same grandeur in the old photographs of the Northern Michigan Asylum, whose grounds were so lovingly planted and tended by Munson and whose beauty has been preserved through community effort. After this exercise in historical reflection, we can look with more interest and appreciation at the old asylum buildings and grounds that remain. When you see them, remember Emerson and Whitman, *The Rocky Mountains* and *Twilight in the Wilderness*, Ebenezer Haskell and Ralph Albert Blakelock. The next time you visit Central Park or some other great urban park, remember their roots in the therapeutic landscape so venerated by Kirkbride and Munson. And hope that those landscapes may be preserved so that future generations may also appreciate their "angels in the architecture."

Notes

1. For a good overview of the history of the mental hospital, see Gerald N. Grob, *The Mad among Us: A History of the Care of America's Mentally Ill* (New York: Free Press, 1994).
2. The discussion of Kirkbride's career that follows is drawn from Nancy Tomes, *A Generous Confidence: Thomas Story Kirkbride and the Art of Asylum-Keeping, 1840–1883* (New York: Cambridge University Press, 1984). Some parts of this introduction appear in different form in the introduction to the paperback edition of *A Generous Confidence*, which was reissued as *The Art of Asylum-Keeping: Thomas Story Kirkbride and the Institutional Origins of American Psychiatry* (Philadelphia: University of Pennsylvania Press, 1994).

3. I discuss the ethical issues involved in Kirkbride's marriage to Eliza Butler at more length in *The Art of Asylum-Keeping*, xxii–xxiv.

4. On moral treatment and the early history of American mental hospitals, see Gerald N. Grob, *Mental Institutions in America: Social Policy to 1875* (New York: Free Press, 1973), and David J. Rothman, *The Discovery of the Asylum: Social Order and Disorder in the New Republic* (Boston: Little, Brown, 1971). Rothman uses the phrase "moral architecture" on p. 84.

5. John Galt quoted in Tomes, *A Generous Confidence*, 284.

6. On treatments used in early asylums, see Grob, *Mental Institutions in America*, and Ellen Dwyer, *Homes for the Mad: Life Inside Two Nineteenth-Century Asylums* (New Brunswick, N.J.: Rutgers University Press, 1987).

7. My appreciation of these historical issues has been further enhanced by reading Kenneth Hawkins, "The Therapeutic Landscape: Nature, Architecture, and Mind in Nineteenth-Century America," Ph.D. diss., University of Rochester, 1991.

8. Barbara Novak, *Nature and Culture: American Landscape and Painting, 1825–1875*, rev. ed. (New York: Oxford University Press, 1995).

9. Catherine L. Albanese, *Nature Religion in America: From the Algonkian Indians to the New Age* (Chicago: University of Chicago Press, 1990.)

10. Perry Miller, "Errand into the Wilderness," *William and Mary Quarterly*, 3rd ser., 10, no. 1 (1953): 3–19.

11. For a good discussion of these works of art, see Novak, *Nature and Culture*.

12. Ralph Waldo Emerson, "Nature," in *The Norton Anthology of American Literature*, ed. Nina Baym et al., 4th ed. 2 vols (New York: W. W. Norton, 1994), 1007.

13. James C. Whorton, *Crusaders for Fitness: The History of American Health Reformers* (Princeton, N.J.: Princeton University Press, 1982).

14. See Hawkins, "Therapeutic Landscape," esp. ch. 1.

15. Pennsylvania Hospital for the Insane, Report, 1863, 24.

16. On the concept of "borderland," see John R. Stilgoe, *Borderland: Origins of the American Suburb, 1820–1939* (New Haven, Conn.: Yale University Press, 1988). Rothman's Discovery also has a good discussion of the rural placement of asylums.

17. On the Friends Asylum, see Tomes, *A Generous Confidence*, 62–67.

18. Quoted in Hawkins, "Therapeutic Landscape," 45–46.

19. For a discussion of the early profession and its meetings, see Tomes, *A Generous Confidence*, ch. 5. The Kalamazoo trustees' asylum tour is mentioned in Henry Hurd, "A History of the Asylums for the Insane in Michigan," *Collections and Researches, Michigan Pioneer and Historical Society* 13 (1889): 296.

20. Kirkbride quoted in Tomes, *A Generous Confidence*, 268; Bell quoted in Hawkins, "Therapeutic Landscape," 40.

21. Northern Michigan Asylum at Traverse City, Annual Report, September 30, 1886, 10.

22. See, for example, Heidi Johnson's photograph of the copper beech (151) and "sister black willows" (70).

23. See Hawkins, "Therapeutic Landscape," esp. part 2.

24. See Hawkins, "Therapeutic Landscape," ch. 2.

25. On Downing's early life and career, see Hawkins, "Therapeutic Landscape," ch. 5. On Kirkbride's early life, see Tomes, *A Generous Confidence*, ch. 2.

26. Downing quoted in Hawkins, "Therapeutic Landscape," 36, 38.

27. Hawkins, "Therapeutic Landscape," 273.

28. Roy Rosenzweig and Elizabeth Blackmar, *The Park and the People: A History of Central Park* (Ithaca, N.Y.: Cornell University Press, 1992).

29. Hawkins, "Therapeutic Landscape," esp. 61–67.

30. *American Journal of Insanity* 12:43 (1855): 89.

31. These letters are housed in Patient Correspondence, Archives of the Institute of the Pennsylvania Hospital.

32. October 11, 1861. For more on Kirkbride's experiences with Wiley Williams and Ebenezer Haskell, see Tomes, *A Generous Confidence*, ch. 5.

33. Quoted in Tomes, *A Generous Confidence*, 258.

Historical Overview

The Northern Michigan Asylum, 1885–2000

This book of photographs begins with a rare look into the gentle formative years of this asylum at the turn of the twentieth century and concludes with a poignant look at the decay and ghosts that have been left behind. The asylum opened its doors in 1885, and by the time it closed in 1989, it had affected 50,000 patients, approximately 20,000 employees, and more than 250,000 visitors. Throughout the century, the asylum and its inhabitants witnessed hardships as well as tremendous societal and medical changes. The Northern Michigan Asylum withstood and even thrived during the Great Depression, World Wars I and II, and the Korean and Vietnam Wars. Overcrowded wards were exposed to deadly epidemics and diseases such as typhoid, smallpox, diphtheria, influenza, syphilis, tuberculosis, polio, and epilepsy. Between 1885 and 1989, approximately 15,000 patients died due to these and many other illnesses that are now treatable and even curable.

At its inception, this institution was briefly named the Northern Michigan Asylum for the Insane, but in 1885 it was officially named the Northern Michigan Asylum by Public Act No. 155. The name changed several times, from the Northern Michigan Asylum to the Traverse City State Hospital in 1911 and finally to the Traverse City Regional Psychiatric Hospital in 1978.

During the asylum's one hundred years, doctors used many well-meaning but mostly ineffective and often cruel therapies for patients. Psychotropic drugs were not invented until the 1950s, which means that patients in the early years of the asylum were offered no curative drug treatments. Opium and morphine were the only drugs available, and they were used in small amounts primarily as sedatives for agitated patients. Between 1885 and 1920, "the moral treatments" of kindness, exposure to beauty, and voluntary work were considered the primary therapy for all patients. Restraints were strictly forbidden, and sincere attempts were made to incorporate every comfort and

pleasantry into asylum life, with the purpose of inducing patients' recovery. There were pianos or organs on every floor, nightly sing-alongs in the dayrooms, and well-used fireplaces in the cottages. Freshly cut flowers, provided by the asylum greenhouses, were supplied to the wards year-round. Therapeutic patient treatments included going to picnics, local fairs, and circuses, and playing shuffleboard or croquet on the asylum lawns. Though they may sound idealized, these kindnesses were carefully planned treatments based on the Kirkbride plan and the "moral treatments" dutifully implemented by Dr. James Decker Munson, the first superintendent of the Northern Michigan Asylum. Munson believed that voluntary work would benefit the patients by giving them a sense of purpose and accomplishment. Patients engaged in work ranging from building furniture and fruit canning to farming and flower-growing.

By 1918 the quiet life and moral treatments inside the asylum were slowly slipping away. Worn and soiled rugs were no longer replaced, and wall hangings, houseplants, and small tables were eventually destroyed by patients. The plaster walls of the wards that were once decorated with phrases of encouragement such as "Kindness keeps friends" and "After Clouds, Sunshine," were painted over with layer upon layer of institutional lead paint. In the 1920s, new patient therapies began to take the place of moral treatments. These well-intentioned therapies were uncomfortable at their best and deadly at their worst. Bizarre by today's standards, therapies implemented over the years at the Northern Michigan Asylum/Traverse City State Hospital included drinking a tonic made of "proto-iodide of mercury and the fluid extract of cocoa." In other treatments, consuming various amounts of valerian root, belladonna, borax, arsenic, opium, and morphine were reported to be helpful in the treatment of "insanity." One gentler treatment—hydrotherapy—involved long baths in deep, warm water, but most therapies were not so benign. One of these was "fever inducement," a short-lived treatment for syphilitic insanity used between 1935 and 1940. It involved a patient being heated inside a metal cabinet until a fever was induced. Other temperature-related treatments included wrapping ice-filled tubes around a patient's head, and "neutral pack"—a treatment in which a patient was wrapped like a mummy and dipped into cold water.

Treatments became more invasive in the 1940s and 1950s when doctors used therapies such as induced insulin shock, induced metrazol shock, lobotomies, and the most feared, yet widely used treatment, electroshock therapy. By March 26, 1947, more than thirty thousand electroshock treatments had been administered at the Traverse City

State Hospital. Induced insulin shock was a particularly unusual treatment because it produced miraculous results that, sadly, were only temporary. To induce insulin shock, a doctor would inject a patient with insulin until the patient went into shock. During this procedure a nurse would always be near with a hypodermic needle full of adrenaline in case the patient's heart stopped. Once the patient was in shock, the doctor would inject glucose, and as the patient was coming out of shock he or she would experience a few moments of complete lucidity—complete "sanity." Nurses recall how amazing this transformation was to observe, even though it was painful to watch their patients, after a short time, slowly slip back to their previous state of mental illness. By the 1950s nearly all of these "therapies" were replaced—except electroshock, which was used into the 1970s—with psychotropic drugs such as Ritalin, Thorazine, and Serpasil.

With the success and gradual increase of drug therapies, more patients left the hospital improved or cured. This exodus, combined with accusations of civil rights violations and severe cuts in state funding, caused the Traverse City Regional Psychiatric Hospital to close in 1989, despite bitter resistance from employees, patients, and local residents. In the months and years following the hospital's closing, many former patients with continuing mental health problems were found to be homeless, in the jail system, or in inadequate and unaffordable private care. In recent years, groundskeepers have encountered former patients revisiting the abandoned institution and attempting to enter the buildings again, not as vandals, but as people who missed the only place many of them had called "home."

JAMES DECKER MUNSON, 1848–1929

James Decker Munson was born June 8, 1848, on his parents' farm in Oakland County, Michigan. As a boy, he worked diligently on his father's land, learning the trade of farming. Although Munson possessed a lifetime love of the soil, he set his sights on medicine. He attended high school in Pontiac, Michigan, and afterward enrolled in the University of Michigan in Ann Arbor. In 1873 the twenty-five-year-old Munson graduated with a degree in medicine from the University of Michigan's Allopathic School of Medicine. That same year, Munson started his first private practice in

PORTRAIT OF DR. JAMES
DECKER MUNSON,
circa 1925

Courtesy of the
Grand Traverse Pioneer
and Historical Society

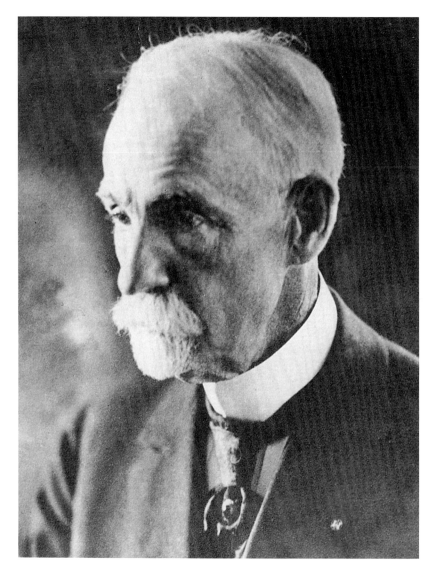

Detroit and quickly became a successful and sought-after practitioner. By age thirty, his reputation had grown. Munson was considered an honored consultant and speaker, often called upon by fellow doctors many years his senior.

Around 1874, while teaching at the Detroit College of Medicine, Munson became fascinated with psychiatry. As a lecturer of anatomy, he worked with cadavers and developed an interest in the neurological-tissue differences between brains of the sane and insane. He spent hours in the college's lab analyzing brain tissue under the microscope, wrote detailed papers on his neurological findings, and gave numerous lectures around the Detroit area on the topic.

In 1878 Munson was first choice for the chief medical assistant position at the new Eastern Michigan Asylum, under its first superintendent, Dr. Henry M. Hurd. Prior to beginning in Pontiac, Hurd sent Munson to the Michigan Asylum for the Insane in Kalamazoo for several months of residency. After his return, Munson was able to study myriad pathologies firsthand and work directly with Dr. Hurd. In 1880, while working in Pontiac, Munson married Mary, his first wife, and soon after they had their only child, a son, James Fredrick Munson. In September 1885 Munson was appointed chief medical superintendent of the new Northern Michigan Asylum that was due to open in November of that same year.

The Munson family arrived in Traverse City by rail in November 1885 along with forty-three patients and nursing staff from the Pontiac asylum. Munson moved his family into the Center Administration Building on the opulent second floor, located between the men's and women's wings of Building 50. Within one month of his arrival, the asylum's population had grown to more than four hundred patients. Munson followed the new psychiatric "moral treatments" of the day that called for the gentle care of patients by providing them beautiful surroundings, clean, homelike wards, and large amounts of encouragement from the staff. It was believed that if these elements were combined with fresh air, good food, and voluntary work, a cure rate of 90 to 100 percent could be expected. In conjunction with this new treatment method, Munson refused the use of the straight jacket or any other kind of restraints on his patients unless dire circumstances required it.

Munson's extraordinary compassion for his patients was widely known. During the first years of the asylum, every patient was under Munson's care. He was both their medical doctor and their psychiatrist. Families were to contact Munson directly with questions about their loved ones, and Munson approved each patient's admission or

release from the asylum. He made daily rounds of the entire hospital and grounds and reportedly knew the name and diagnosis of nearly five hundred patients.

In the spring of 1886, Munson decided to clear hundreds of tree stumps from the asylum grounds. Records show that the first voluntary work by male patients was clearing these stumps (only male patients did outside labor). Following his plan for both a beautiful arboretum and a large working farm—both considered therapeutic and integral to the implementation of the moral treatments—Munson had much of the newly cleared land immediately tilled for farmland. As for the arboretum, Munson was known to have personally selected many of the plant species that would grow just outside the patient wards and planted many of them himself. It took a few years for Munson's arboretum to become beautiful, but the farm produced a good first harvest within nine months of the asylum's opening. By September 30, 1886, Munson's farm and new dairy herd had produced the following (in part): 40 bushels of apples, 300 bunches of celery, 26 bushels of tomatoes, 117.5 bushels of sweet corn, 38,488 quarts of milk, 602 pounds of veal, and 5,922 pounds of pork. All of this was primarily planted, nurtured, harvested, prepared, and consumed by the patients.

Landscaping the asylum grounds with beautiful flowering plants and trees was another of Munson's joys and became a lifelong labor of love: over the years, Munson and his wife traveled to various parts of the United States and with every return brought home exotic trees and shrubs. Many of their cuttings were cultivated in the asylum green-house and, when strong enough, planted throughout the grounds: Some plant species did not survive in the new climate, but many others did and the Munsons were known to be very pleased to see their adopted plants thrive in Michigan soil. To this day, several of Munson's rare transplants, including tulip tree, sweet gum, Russian olive, and gingko still grace the grounds.

Another detail of Munson's dedication to earth and beauty was the cultivation of flowers in the asylum green-house. Year-round, hundreds of flower varieties were grown in the hothouses—chrysanthemums, roses, orchids, carnations, poinsettias, geraniums, and even orange and lemon trees. Throughout the winter, fruits and vegetables continued to grow in the greenhouse, supplying the asylum with large quantities of vegetables and fruits.

By summer of 1902, Mary Munson was very ill with an unnamed but prolonged illness. She reportedly died peacefully on the evening of July 4, 1902. She was buried in the Munson family plot in Pontiac, Michigan. Two years later, in 1904, Munson married Miss Marian Ward from Manistee, Michigan.

In 1906 Munson established a training school for nurses at the asylum. Prior to the establishment of the nursing school, Munson had trained young men and women from local farms as nurse attendants. The only requirements for entrance to his new school were good health and two years of high school. Due to a lack of instructors, Munson asked for assistance from his doctor colleagues in Traverse City, and they graciously taught the classes. The first class of nurses graduated in 1908, and for the next forty years, the institution graduated a class of new nurses every spring.

The seed for what would become the James Decker Munson Hospital in Traverse City was planted in 1915 when Traverse City's only medical hospital burned to the ground. Munson recognized the urgent need for a replacement hospital until a new one could be built. He quickly modified an asylum cottage and offered it to the community of Traverse City to use as a temporary hospital. The two-story house/hospital was located one block from the asylum at the corner of 11th Street and Elmwood Avenue (Building 88). The tiny hospital became a success and everyone benefited from its operation. While the "cottage" gave the community a medical hospital, it also gave Munson a facility in which to train his nurses. Nearly all the needs of the small hospital were absorbed by the asylum. Every service, from laundry and food to heat and power, was provided by the massive institution.

In the fall of 1918, the worldwide pandemic of the flu reached the village of Traverse City and the Traverse City State Hospital. By November all public gatherings were banned. All theaters were closed and church services were cancelled. Police were even given authority to send "coughers" into seclusion. Despite everyone's best efforts, the virus spread quickly throughout the town and the asylum. Munson's small hospital was overcrowded and many townspeople were turned away. Ironically, while Dr. Munson was fighting the epidemic in Traverse City, the flu claimed the life of his only child, Capt. James Fredrick Munson. The young Munson, a trained pathologist, had enlisted in the army during World War I. Munson, recently married, died when the disease ravaged his crowded army camp in Plattsburgh, New York. Sadly, when his body was returned to Michigan in late October, his memorial service in Traverse City had to be delayed until after the epidemic subsided. The loss of his son reportedly devastated the normally composed Dr. Munson.

Munson likely had little time to grieve for his son, as the virus continued to spread throughout Traverse City and northern Michigan. By Christmas the small hospital was overrun, and on December 27, 1918, Dr. Munson

opened the men's receiving ward of the asylum to the residents of Traverse City. The ward, also known as Cottage 20, was transformed into an emergency medical hospital that provided an additional sixty beds to those stricken with the flu and pneumonia. Fortunately, the disease soon ran its course, and by mid-January 1919 the epidemic was over. The asylum cottage was closed as a hospital unit and reopened as a men's psychiatric ward.

After eight years of running the small hospital, Munson had saved over $35,000 in expenses. He put this money into a general hospital fund for the building of a new hospital. In 1923 a state auditor, after looking over the state accounting books, would not recognize Munson's fund as official, and the $35,000 was placed into a state general fund. Munson immediately formed a thirty-man committee and appealed to the governor. The governor reported that the money was already gone, but shortly after his response, a bill was passed that appropriated $78,000 for the building of a new hospital in Traverse City.

Despite this victory, in July 1924, at the age of seventy-six, Munson retired as superintendent of the Traverse City State Hospital. He and his wife, Marian, retreated to their beloved farm on the Mission Peninsula of Grand Traverse Bay. After thirty-nine years at the state hospital, in July 1926 Munson was honored at the opening and dedication of the new James Decker Munson Hospital.

James and Marian Munson had a quiet year together on their farm until Marian died suddenly of a brain tumor on August 23, 1927. After Marian's death, Munson was left alone except for a few relatives who lived in New York and San Francisco. Dr. E. F. Sladek, Munson's personal friend and physician, was with Munson during his last days and years later recalled the sad end of an extraordinary life. Munson's health began to fail in 1929. After returning from a trip to San Francisco, Munson fell in a Grand Rapids, Michigan, hotel room, and fractured his hip. Munson did not want to go to the hospital and insisted on returning to his farm on the peninsula. Once home, he stayed in bed. He allowed Sladek to apply massive elastic bandages to his hip for support but refused to be X-rayed. Although Munson had caretakers who cleaned and cooked for him, Sladek reported that Munson was discouraged and lonely during the last months of his life. He died on June 24, 1929, at age eighty-one, of hypostatic pneumonia. He is buried in Oak Hill Cemetery in Pontiac, Michigan, near his mother, his father, and his son and beside his first wife, Mary.

Angels in the
ARCHITECTURE

WILLOW LAKE,
Northern Michigan Asylum

Photograph by
William Petertyl, 1936.
Private collection of Julius Petertyl

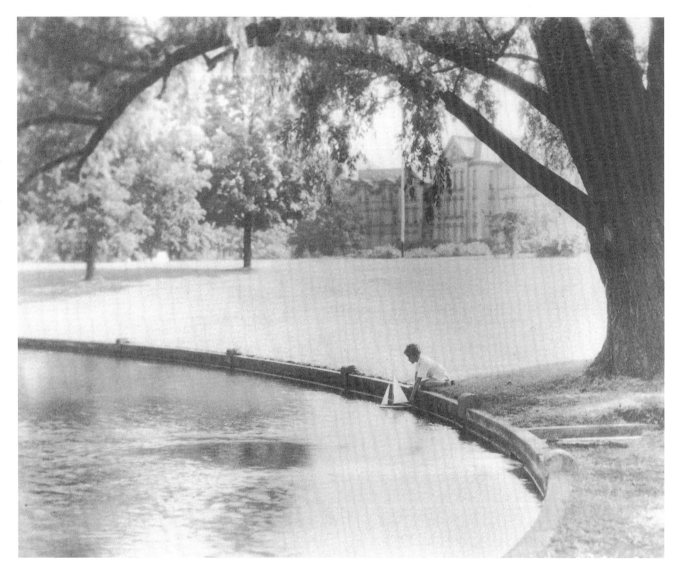

The Insane Asylum—1885

It is easy to be seen what a beautiful place the location must ultimately become; for here amid these romantic hills, where water from several crystal springs abounds, where leafy flowers and groves of shade in summer time, afford almost a paradise for rest, these wasted unfortunate creatures of mental disease from the asylum can go and commune in silence with the great Creator; and then gazing out upon the grand old bay, the waters of which are lazily though musically, tossed upon the beach at their feet, they can watch the vessels passing up and down the harbor in quiet contentment, which may prove an aid in inviting back reason to brains diseased and restoring health to forms emaciated. Michigan, my Michigan, we are proud of thee and it is not perhaps that we are fully and consciously made aware of the wisdom, foresight, benevolence, and charity of thy rulers and thy people until we stand in admiration at the portals of institutions similar in character to the Asylum now approaching completion and to be thrown open for occupancy in the coming October.

Grand Traverse Herald, Traverse City
July 23, 1885

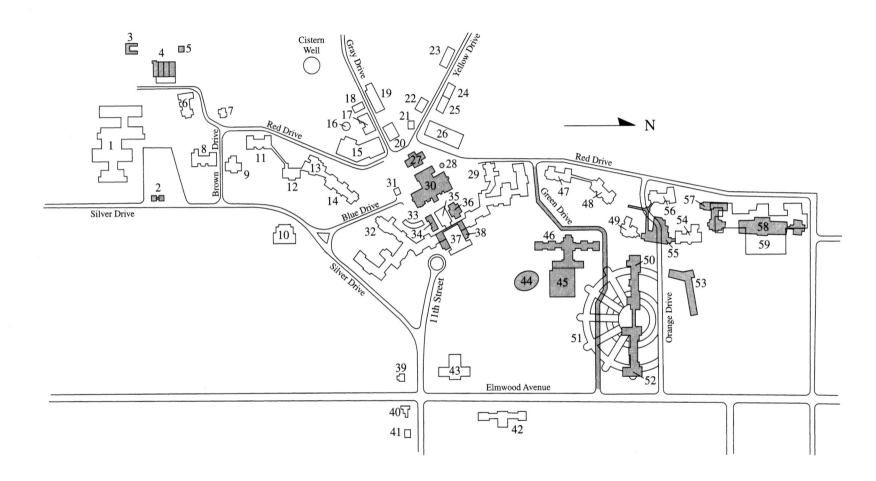

Cistern Well

Gray Drive

Yellow Drive

Red Drive

Brown Drive

Silver Drive

Blue Drive

Silver Drive

11th Street

Green Drive

Red Drive

Orange Drive

Elmwood Avenue

N

Main Campus

Shaded buildings have been demolished.

1. Arnell Engstrom Children's Hospital, est. 1969
2. Original Munson carriage barns, est. 1885, demolished 1940s
3. Coal bunker
4. Original greenhouse, est. 1892; new greenhouse built in footprint, demolished 1950s
5. Bulb storage house, est. 1910, demolished c. 1960
6. Original men's Cottage 36, later children's cottage, est. 1903
7. Original engineer's residence, later gardener's residence, est. 1890
8. Men's Cottage 34, est. 1899 for "curable" patients
9. Men's Cottage 32, former tuberculosis ward, est. 1889
10. Power house, est. 1948
11. Men's Cottage 30, est. 1901
12. Men's Cottage 28, geriatric ward, est. 1887
13. Men's dining room/auditorium, est. 1915
14. Second floor of men's Cottage 24 (a.k.a. Cottage 40), est. 1893
First-floor men's hospital ward 26 (a.k.a. Cottage 40), est. 1893
15. Institution storage, bakery, walk-in coolers, est. 1920/1952
16. Water tower
17. Carpentry and furniture repair, est. 1931
18. T.V. repair shop, est. 1932
19. Machine and electrical shop, est. 1930
20. Original upholstery shop/occupational therapy, est. 1917
21. Original fire house, est. 1890, later converted to potato-peeling house
22. Rag and soap house, est. 1916
23. Staff garage, est. 1934
24/25. Fruit and vegetable warehouse, est. 1900/1910
26. Laundry building, est. 1956
27. Original laundry building, est. 1890, demolished 1940s
28. Coal smoke stack
29. Women's receiving ward (a.k.a. Cottage 19), Building 50, est. 1889
30. Original shop building, est. 1893, demolished 1940s
31. Original fire hall, est. 1928
32. Men's receiving ward (a.k.a. Cottage 20), Building 50, est. 1889
33. Superintendent's and officers' garage, est. 1916
34. Original bakery, est. c. 1890, demolished 1940s
35. Original chapel building, est. 1885 (chapel converted into patient library, 1930s)
36. Original icehouse and meat storage house, est. 1885, demolished 1940s
37. Former nurses training area and Traverse City State Hospital administrative offices, Building 50A, est. 1963
38. Center of Building 50, a.k.a. Old Center, original asylum main entrance, administrative offices, and superintendent/officer residence, est. 1885, demolished 1963
39. Former assistant superintendent's residence, est. 1905
40. Oldest building on asylum campus, Building 88, former private residence, est. c. 1879
41. Staff apartments, est. 1931
42. Nurse and employee housing, est. 1938
43. All Faiths Chapel, est. 1963
44. Willow Lake reflection pool, est. c. 1900, removed 1995/1996
45. Hospital administration, est. 1957, demolished 1995/1996
46. Receiving hospital, est. 1938, demolished 1995/1996
47. Women's Cottage 21, wards for working female patients, est. 1901
48. Women's Cottage 23, est. 1901, later converted into coed patient housing
49. Women's Cottage 25, former tuberculosis ward and, from 1987 to 1991, a hospital museum, est. 1891
50. Geriatric hospital, Building 33, est. 1930, demolished 1995/1996
51. Grand Traverse Pavilions, est. 1997
52. Geriatric hospital, Building 35, est. 1930, demolished 1995/1996
53. One-hundred-bed tuberculosis hospital, Building 41, est. 1953, demolished 1995/1996
54. Women's Cottage 29, geriatric ward, est. 1893
55. Women's dining room/auditorium, est. 1924, demolished 1995/1996
56. Women's Cottage 27, epileptic ward, est. 1903
57. Original student nurses home, est. 1902, demolished 1940s
58. Original James Decker Munson Hospital, est. 1926, demolished 1950s
59. Munson Medical Center

BUILDING 50

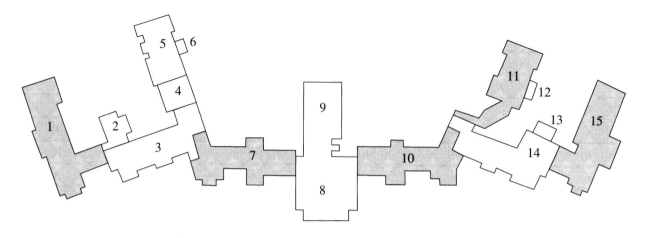

FOLLOWING THE KIRKBRIDE PLAN, the Northern Michigan Asylum separated men and women patients by placing them in opposite ends of Building 50, on either side of the Center Administration Building. Male patient wards were located on the south wing of Building 50 and were always designated by even numbers, such as wards 6, 12, and 18. The female patient wards were located in the north wing and were always designated by odd numbers, such as wards 5, 11, and 17. This even/south/male and odd/north/female system was also used in cottage placement and identification.

MEN'S WING
Even-numbered wards

1. Men's "most-disturbed" wards 6, 12, 18
2. Men's dining rooms and kitchens
3. Men's intermediate wards 4, 10, 16
4. Nurse dormitories
5. Men's ward 20, a.k.a men's receiving ward
6. Men's operating room
7. Men's convalescence wards 2, 8, 14
8. Old Center
9. Chapel, library, and employee kitchen/dining area

WOMEN'S WING
Odd-numbered wards

10. Women's convalescence wards 1, 7, 13
11. Women's ward 19, a.k.a. women's receiving ward
12. Women's operating room
13. Women's kitchen and dining area
14. Women's intermediate wards 3, 9, 15
15. Women's "most-disturbed" wards 5, 11, 17

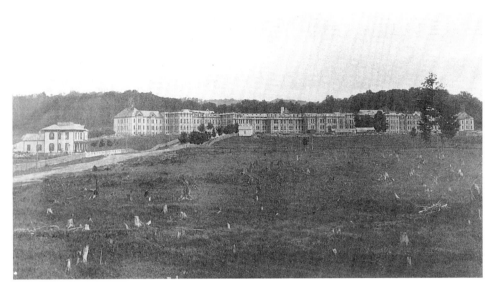

BUILDING 50 OF THE NORTHERN MICHIGAN ASYLUM, under construction, summer 1884. Also shown at left is Building 88, a private dwelling included in the original asylum land purchased in 1881. In 1885 this home was modified into a home for fifteen female patients. In later years, this home served as employee housing and in 1915 was converted into a hospital by James Decker Munson

Courtesy of the Con Foster Museum

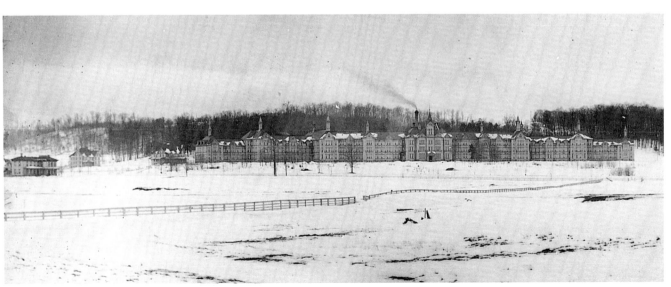

NORTHERN MICHIGAN ASYLUM, winter 1892. *Left to right*: Building 88, Cottage 32, Cottage 28, and Building 50

Courtesy of the Grand Traverse Pioneer and Historical Society

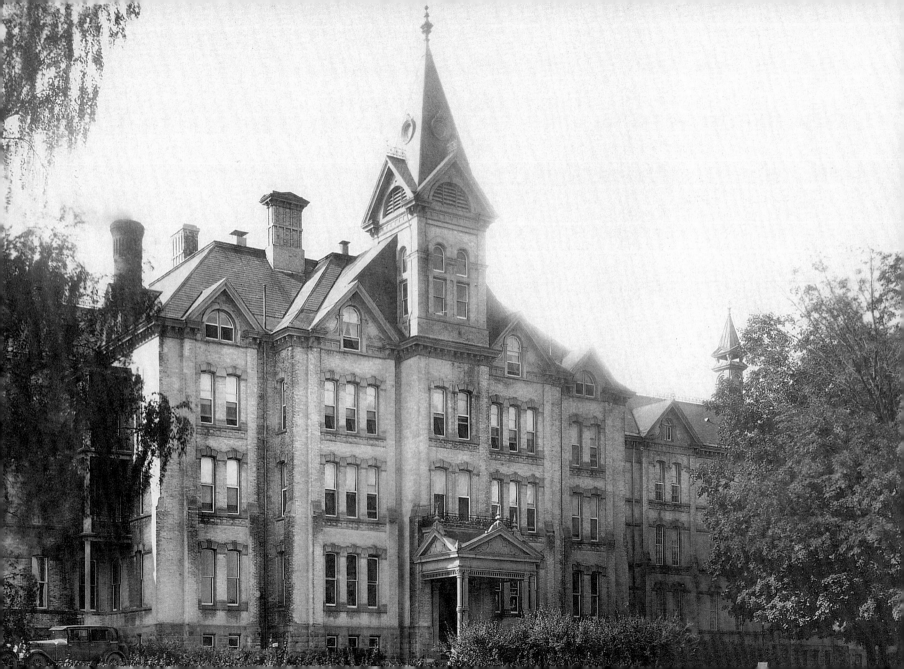

Old Center

Old Center was a very special place to me because I grew up there. I lived on the second floor from age seven until I left in 1944 to attend college. My father, Dr. R. P. Sheets, was the fourth superintendent of the then Traverse City State Hospital and held the position from July 1, 1931, to January 3, 1956.

Since this beautiful building is long gone, let me tell you what the inside of grand Old Center was like when I lived there. As one entered the lobby up well-worn cement steps using a well-polished brass rail (kept in pristine condition by a patient named Ben L.), one faced a majestic staircase that led up to the super-intendent's living quarters. Also in the front lobby was the superintendent's office, located off to the left (the outside three windows left of the portico). His secretary's office was on the left side of his office (two windows next to his three). To the right, off the lobby, was the resident physician's office. There were other staff offices on the first floor, including the patient reception area, the switchboard, the post-office room, the accounting and bookkeeping rooms, the supervisor of nursing's office, and the office of social services. The pharmacy was located in the basement, as well as the "special kitchen" that prepared the meals for the occupants of Old Center. The "special kitchen" was once the original central kitchen for the entire asylum, and food was delivered via trolley cars from there to the patient wards in Building 50. At this time all the canning for the asylum was also done in this basement kitchen. Patients still prepared most of the fruits and vegetables for canning, and the odors were just heavenly—I especially recall the fragrance of a chili sauce that was just to die for.

Opposite Page:

BUILDING 50,
Old Center administration and
residence of medical personnel,
circa 1921

Courtesy of the
Grand Traverse Pioneer
and Historical Society

The second floor contained the superintendent's "apartment," which extended to include the area above the portico (left past the five windows and two windows to the right). On the third and fourth floors were the living quarters for professional staff, such as the resident medical officers and the director of nursing. Each floor had its own dining room where food was sent up from the special kitchen via a dumb waiter.

Having an opportunity to be raised under such unique circumstances gave me a foundation for life that no other experience could have provided. The compassion, caring, and understanding I learned for other human beings could never have been learned in an outside environment. In those days, there was so much ignorance and fear of mental illness (not unlike today in some respects) that there were parents in the community who would not let their children play with me. As a result, I spent most of my childhood with adults and in the process learned a lot about the workings of the institution and how the patients were cared for. It still aggravates me to hear so called snake pit stories about the Traverse City State Hospital when, our patients were treated with respect and, in many cases, love. I never even thought of the patients as people any different from those one might meet on the street. True, they may have dressed in a bizarre manner (what's so different from today?), they may have held conversations with themselves (is that all bad?), or they might have had conversations, heated or friendly, with their hallucinations, but that was all part of life in that environment. I learned from an early age that those actions were beyond the control of the patients, and one just learned to accept it and them.

Recollections of Margaret Sheets Wolf, daughter of former Traverse City State Hospital superintendent R. P. Sheets.

Opposite Page:

NORTHERN MICHIGAN ASYLUM
looking north. *Left to right:*
Cottages 30, 28, 24–26, 20,
Buildings 50, 80, 88,
asylum vineyard located
middle/center, circa 1905

Courtesy State Archives of Michigan

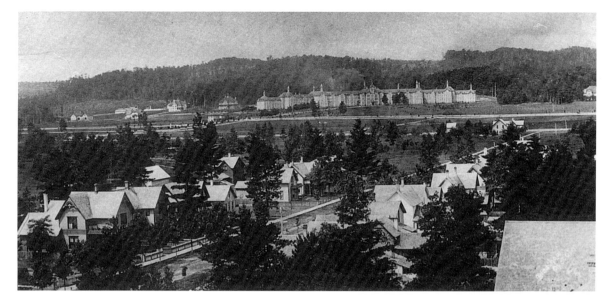

The Northern Michigan Asylum looking west, taken from the roof of town schoolhouse, circa 1894

Courtesy of the Con Foster Museum

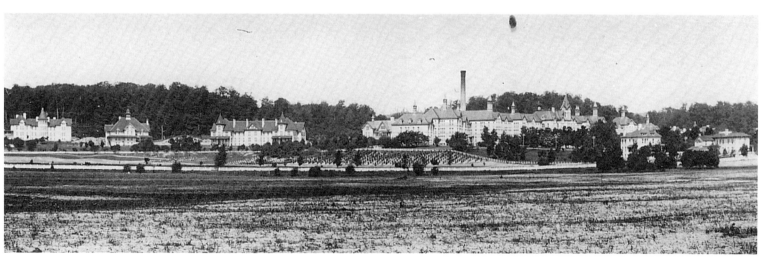

37

VIEW UPON ENTERING OLD CENTER, circa 1890, where less-afflicted patients were admitted and assigned to a ward. From the ceramic-tiled lobby, the grand stairway, shown here, led to the superintendent's private residence on the second floor, the officers' residences on the third floor, and apartments for senior staff and visitors on the fourth floor. In 1962 it was decided by the state that these large, open wooden stairways posed a severe fire risk. Due primarily to the risk, the entire building was demolished in the winter of 1963.

Courtesy of the Grand Traverse Pioneer and Historical Society

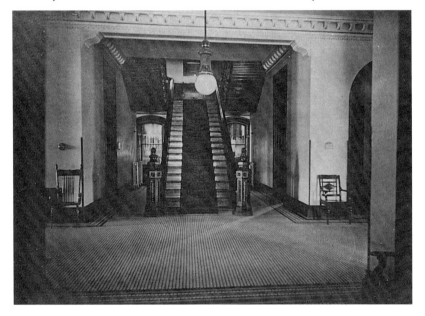

SECOND-FLOOR HALLWAY in superintendent's residence. Stairway on the right led to the apartments of the asylum medical officers and director of nurses, circa 1890.

Courtesy State Archives of Michigan

OFFICES OF RESIDENT
PHYSICIANS, first floor,
Old Center, circa 1890

Courtesy State Archives
of Michigan

STAFF DINING ROOM,
circa 1890

Courtesy State Archives
of Michigan

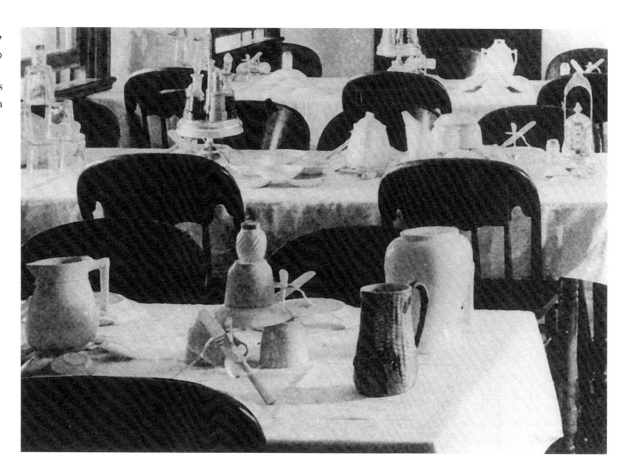

ASYLUM BOARD OF TRUSTEES in parlor room,
Old Center (*Dr. Munson in center*), circa 1909

Courtesy of the Con Foster Museum

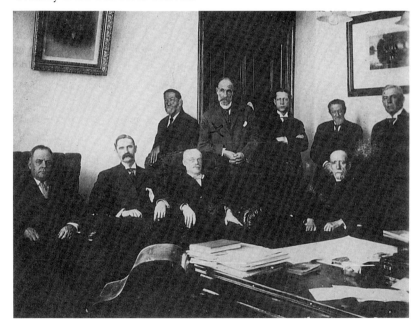

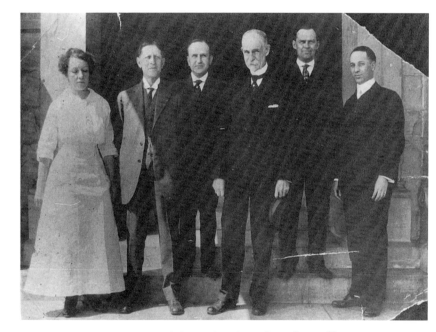

DR. MUNSON (*in center, with hat in hand*) with asylum officers, circa 1919

Courtesy State Archives of Michigan

41

OLD CENTER, Building 50,
circa 1900

Private collection of Mary Rockwood

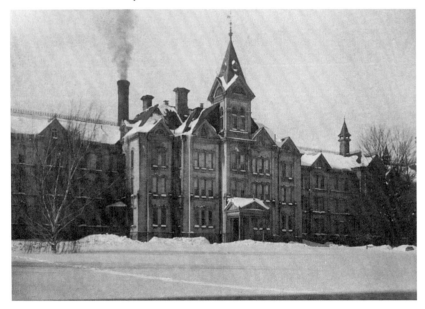

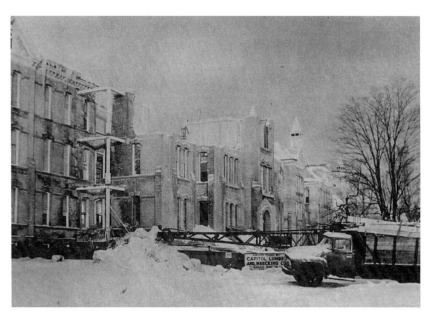

DEMOLITION OF OLD CENTER,
February 1963

Courtesy of the Grand Traverse Pioneer
and Historical Society

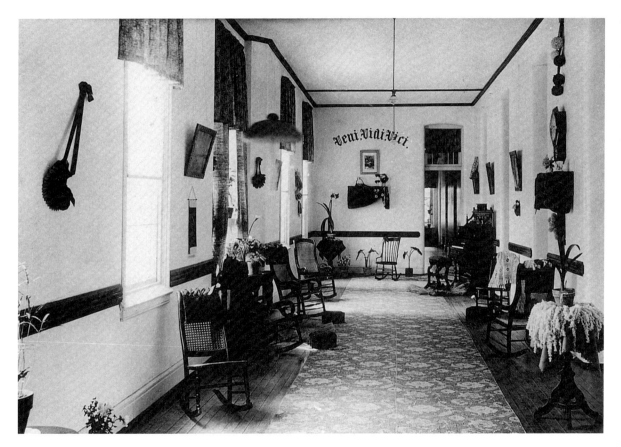

"Veni, Vidi, Vici"
(I came, I saw, I conquered),
women's ward 5, 11, or 17,
Building 50, circa 1890

Courtesy State Archives
of Michigan

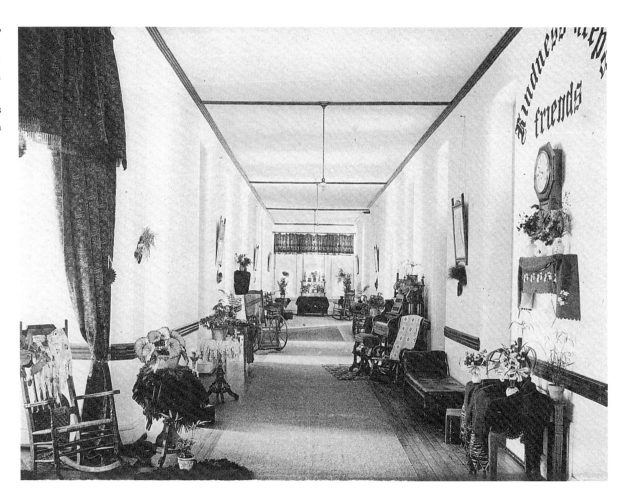

"Kindness keeps friends,"
women's ward,
Building 50, circa 1890

Courtesy State Archives
of Michigan

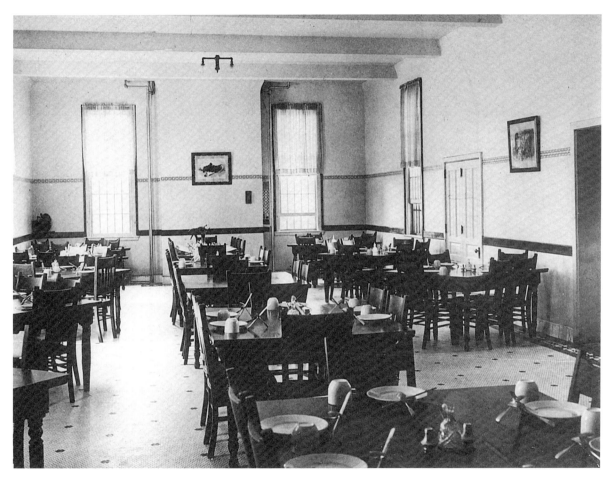

PATIENT DINING ROOM,
Building 50, circa 1905

Courtesy State Archives
of Michigan

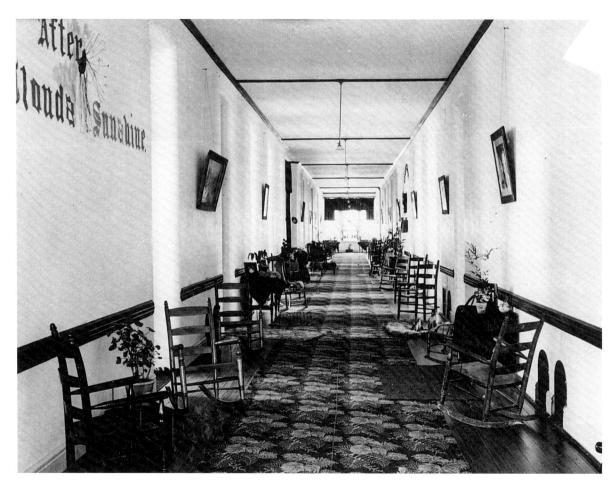

"After Clouds, Sunshine,"
women's ward,
Building 50, circa 1890

Courtesy State Archives
of Michigan

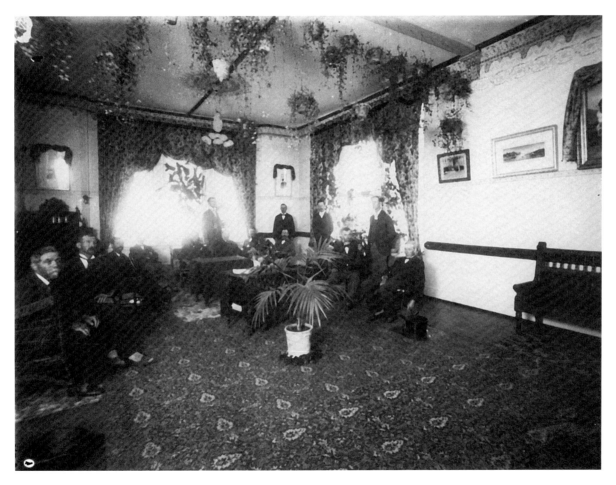

MEN'S DAYROOM
CONVALESCENCE WARD,
Building 50, circa 1890

Courtesy of the
Grand Traverse Pioneer
and Historical Society

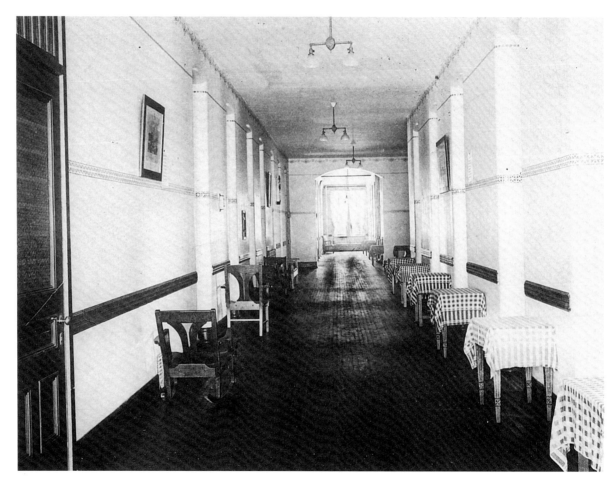

HALL 6,
men's "most disturbed"
ward, circa 1890

Courtesy State Archives
of Michigan

Opposite Page:

PATIENT ROOM IN MEN'S
CONVALESCENCE WARD,
Building 50, circa 1920

Courtesy State Archives
of Michigan

Appearances

A few of the best rooms had the luxury of a wooden dresser. . . . There were few and usually empty since the possessions were not as a rule kept by the patient. Typical bed linen was one bed pad about 4/4, two sheets, a pillow case, and one black blanket, sometimes two. The bedspread was carefully removed from the bed about 4 P.M. before the patient could enter her room to go to bed, and carried out and stacked with the other spreads neatly folded and put away. Then after the patient had left the room for the day the bed was made and the spread put back on . . . and the door locked. Most of these spreads wore well . . . and were seldom if ever seen by the patient.

From the journal of Donna Garn Pillars,
former assistant director of nursing,
Traverse City State Hospital, 1928–74.

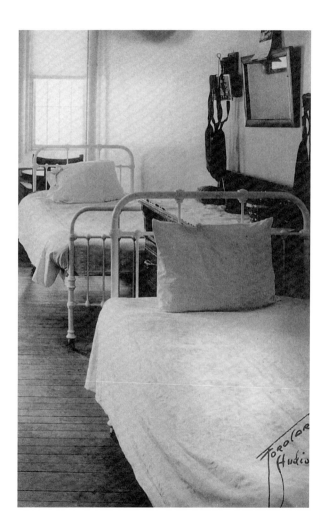

WOMEN'S RECEIVING
WARD (a.k.a. Cottage 19),
Building 50, circa 1890

Courtesy of the
Grand Traverse Pioneer
and Historical Society

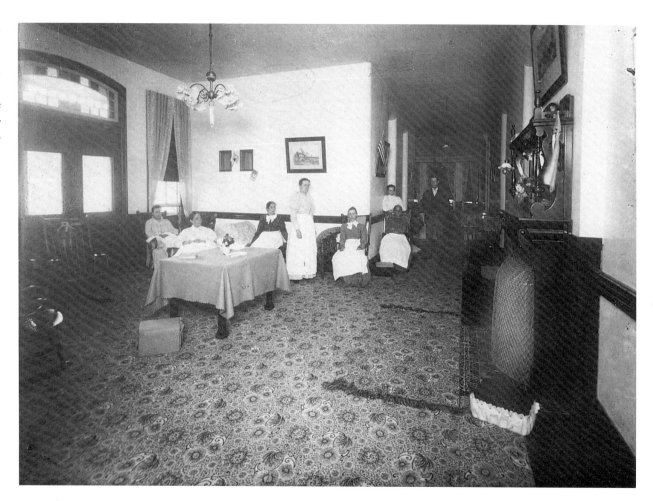

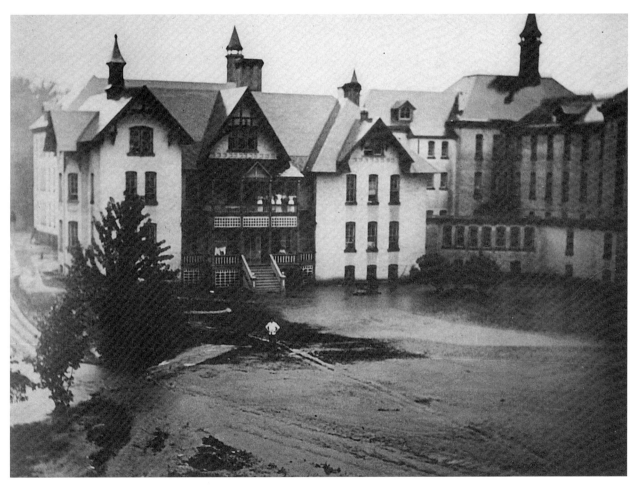

FLOODING IN FRONT
OF COTTAGE 19,
Building 50,
circa 1900

Courtesy State Archives
of Michigan

PATIENT DINING AREA, Building 50, circa 1895

Courtesy State Archives of Michigan

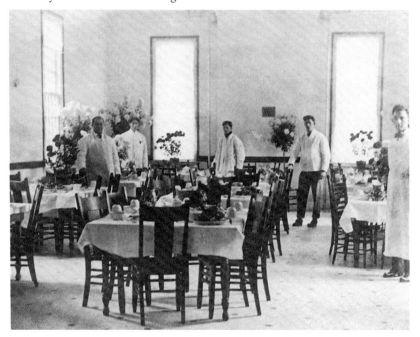

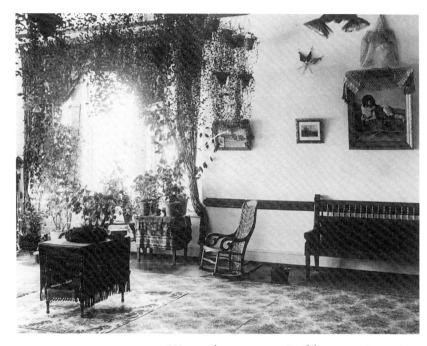

WOMEN'S DAYROOM, Building 50, circa 1890

Courtesy State Archives of Michigan

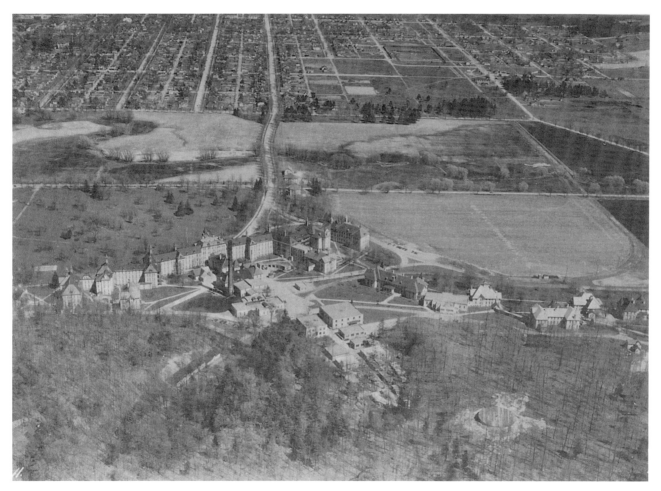

TRAVERSE CITY
STATE HOSPITAL,
aerial view 1,
circa 1930

Courtesy State Archives
of Michigan

TRAVERSE CITY
STATE HOSPITAL,
aerial view 2,
circa 1930

Courtesy State Archives
of Michigan

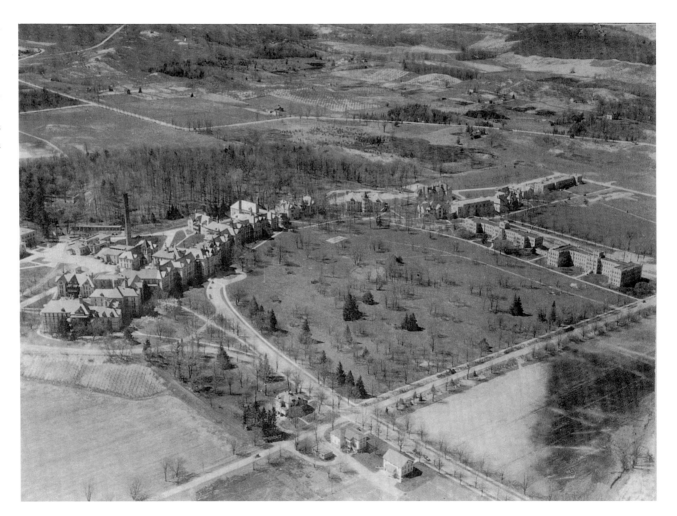

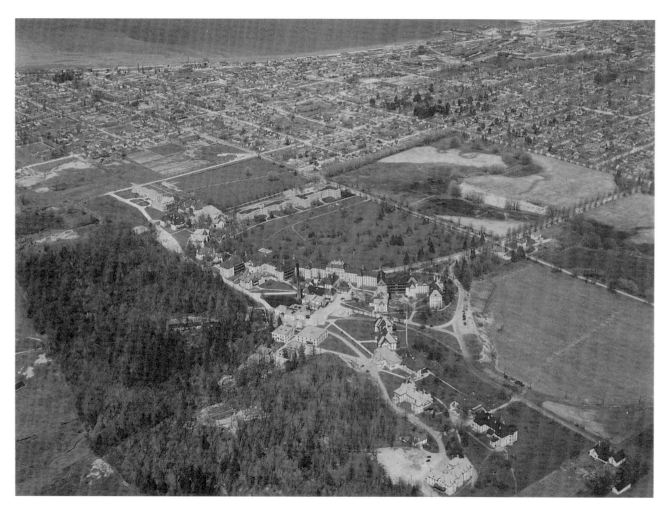

TRAVERSE CITY
STATE HOSPITAL,
aerial view 3,
circa 1930

Courtesy State Archives
of Michigan

TRAVERSE CITY
STATE HOSPITAL,
aerial view 4,
circa 1965

Courtesy of the
Grand Traverse Pioneer
and Historical Society

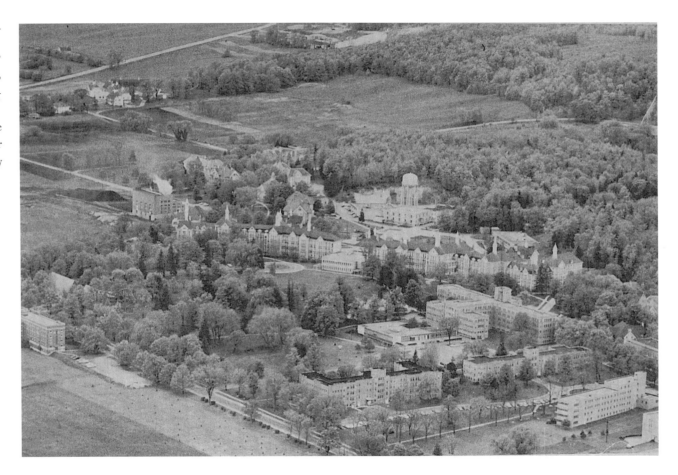

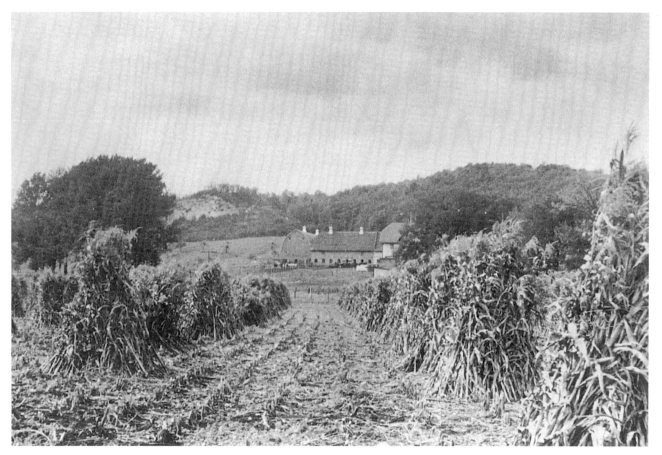

CORN HARVEST AND
TRAVERSE CITY STATE
HOSPITAL BARNS,
circa 1935

Courtesy of the
Grand Traverse Pioneer
and Historical Society

Original state hospital greenhouse, circa 1925. Demolished in 1934 and replaced with larger greenhouse demolished in 1950s.

Courtesy of the Grand Traverse Pioneer and Historical Society

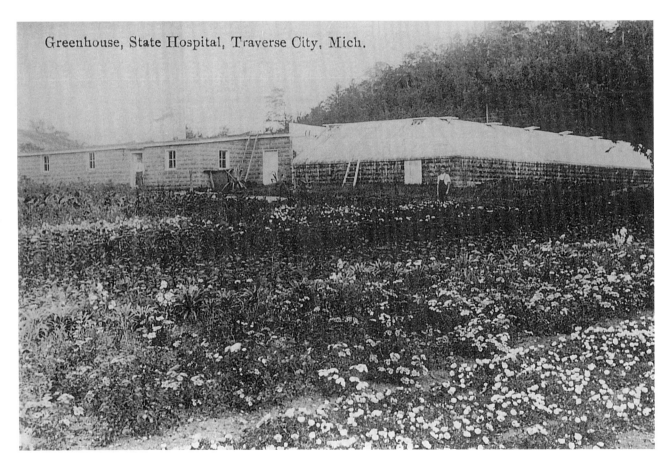

Greenhouse, State Hospital, Traverse City, Mich.

The Day It Rained Glass

I will always remember one day, August 10, 1932. I was about eighteen years old and working with my dad in the old glass greenhouse. At that time he (Edgar Steele) was the head gardener of the entire institution. On that particular day, he was in the greenhouse office and I was working about halfway down in one of the long greenhouses. It had been a perfectly sunny day when we went in but all of a sudden it got very dark in the greenhouse. I turned around to head back to where my dad was to see what was going on when all of a sudden glass was shattering all around me. I took off running and made it to the office (which had a wooden roof) and there my dad and I watched large marble-size hail smash nearly every pane of glass in that greenhouse, six thousand panes total. I will never forget what a huge mess it was but luckily no patients had been working with us that day. It could have been just a horrible situation.

Earle Steele, retired head gardener,
Traverse City State Hospital, 1934–89

ASYLUM DAIRY HERD,
circa 1905

Courtesy of the
Grand Traverse Pioneer
and Historical Society

60

Chrysanthemums Are in Full Bloom—1911

Interesting Study of the Floral Kingdom Can Be Seen in the Greenhouse
at Traverse City State Hospital

"A glimpse of California in Traverse City on a wintry day" is a most appropriate synonym for a trip through the Traverse City State Hospital green houses. To stand at either end of any one of the long glass houses and glance through to the other end, or from side to side is to see a glowing mass of bright, beautiful flowers and foliage that makes exquisite coloring and a rare treat for anyone no matter how much they have traveled to witness scenes perhaps not as interesting as may be seen within the very doors of Traverse City.

Hans Tobler, horticulturist, who has had charge of the Traverse City State hospital gardens for over fourteen years, is deserving of credit for producing the most beautiful flowers grown in Michigan for a state institution. The chrysanthemums at these green houses have long been known to be the most perfect of any grown in this region, and this year they are especially so. In one of the chrysanthemum displays, Mr. Tobler has stalks six feet in height, bearing a single blossom which measures ten inches in diameter with hundreds of curling petals that go to make the blossom not unlike a great ball of sunlight. While yellow is usually associated with chrysanthemums as a color, it is not the only color of this flower that is more often the most beautiful. There are also pink, lavender and red blossoms that are equally as good to look at. Then the soft snowy white flowers are a thing of beauty in themselves and are grown in quantities by Mr. Tobler. One unusually large chrysanthemum tree on display bears over seventy-five large white flowers, and besides numerous buds that when bursting forth into feathery white will tend to make this particular plant like a tree of snowballs.

Roses, carnations, border plants, geraniums and hundreds of others that cannot for lack of space at this time be mentioned are given attention by Mr. Tobler and his assistants, and the result is equally as great as that of the plants described. The arrangement of the plants is worthy of notice, palms, cactus and several others of heavy appearance seem to bank the houses at either end and then along the center are the blooming flowers.

One of the most interesting features of the gardens is the culture of poinsettas, which are just now coming into bloom. For those who have never seen a poinsetta except on picture cards or in a millinery store, it is worth a trip to the big building just to see the real thing. Not now, but just the week before Christmas the poinsetta will be the flower of the season and is much sought by those who know its real connection with Christmastide. The orchid, the flower one reads about often, but which is not grown to any extent in the northern region also has a place of its own in the greenhouses at the State grounds. The species, cultured by Mr. Tobler is a light brown in color with tiny edging of white, and which are covered with tiny brown spots. The orchid is known for its lasting qualities which are greater than any other flower.

Lettuce, in all its stages of growth, from the little leaves springing from the seed to that of the transplants and the product ready for the table is also a sight worthy of notice at this time of year. In one great long space of bare ground which an observer could readily see had at one time been lettuce, a hundred and fifty pounds had been cut only the day before for use on the tables at the main buildings. And yet there are hundreds and hundreds more pounds that will soon be ready for consumption.

Flowers, lettuce and fruits in general are not wonders to the Grand Traverse region, but it is quite rarely that California products, such as lemons and oranges are ventured upon as Traverse City production. Mr. Tobler has one orange tree bearing about twenty oranges. They are not large, but they look like oranges, smell like oranges and really are oranges. He also has lemons, larger than any ever shown in the stores in this city and they were grown in these same gardens.

All this and more is to be seen in Traverse City. Is it not a glimpse of California—and the mere fact that we are in Traverse City and the state of Michigan makes California fade away in the glory of our own city and state.

Traverse City Record Eagle
November 28, 1911

BROKEN LADDER,
in barn #206

Photograph by
Heidi Johnson, 1998

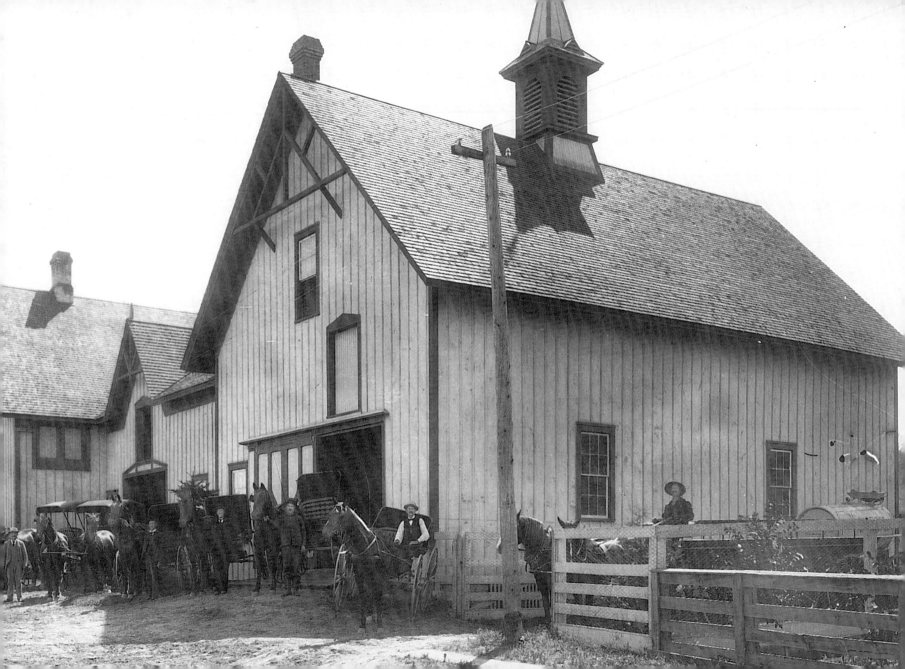

"Who Was Dr. Munson?"

I heard one story. This was in the days of the horse and buggy, and the State Mental Health Commission was coming to town to inspect the institution. They were having a meeting here [Traverse City State Hospital]. And something was wrong—the horses weren't groomed enough or the carriage wasn't as meticulous as it should have been, and evidently, Dr. Munson cracked down on the person who was supposed to have taken care of that and mentioned the fact that how awful it was to have a person so careless as to send out a dirty carriage to meet this very important group of people. Everyone in the institution knew that the first thing Dr. Munson was going to do was to take this Commission—this was in the early days when he was first starting his farm—out to the water melon patch, and he was very, very proud of it, and he was going to show them just what he could do about raising food for the institution. Well, this man got a little bit peeved, and while Dr. Munson drove down to get the Commission—down to the railroad station, which at that time was on Union and 6th Street—this man went out and cut off all the watermelons—removed them all! When Dr. Munson went to show his beautiful patch of watermelons, there wasn't anything there—much to his chagrin.

Talk given by E. F. Sladek, personal friend and physician of
James Decker Munson, recorded on April 21, 1961.

Opposite Page:

———

ASYLUM CARRIAGE BARNS, est. 1886, were also known as the "special barns" by early asylum employees because they housed Dr. Munson's personal horse and buggy. The two barns, demolished in the 1940s, housed six stables, a tack room, several buggies, and the apartment of Munson's personal driver, circa 1890.

Courtesy of the Grand Traverse Pioneer and Historical Society

Barns/Farm Area

Shaded buildings have been demolished.

1. Tuberculosis quarantine barn, est. 1890, demolished 1930s
2. Chicken house, est. 1890, demolished 1930s
3. State hospital wagon and bus storage, est. 1928
4. Original hay barn, Building 204, est. 1932
5. Original calf barn, Building 206, est. 1900
6. Granary and hay storage, est. 1928
7. Original silos in Cyprus wood, est. 1900, demolished 1940s
8. Original cow barns, est. 1898, demolished 1985
9. Farm granary, est. 1951
10. Second milk house, est. 1950, later used for farm chemical storage
11. Milk depot, est. 1900, demolished 1940s
12. Bull pens, est. 1900, demolished 1950s
13. Original ten-stall wagon house, est. 1915
14. Farm scale house, est. 1953
15. Original horse barn, est. 1900
16. Original farm blacksmith shop, est. 1920
17. Tombstone of world champion dairy cow Traverse Colantha Walker, est 1932
18. Cottage 38, original farm cottage for patients, est. 1900, demolished c. 1974
19. Employee residence garage, est. 1890, demolished 1985
20. Employees' residence, est. 1890, demolished c. 1984

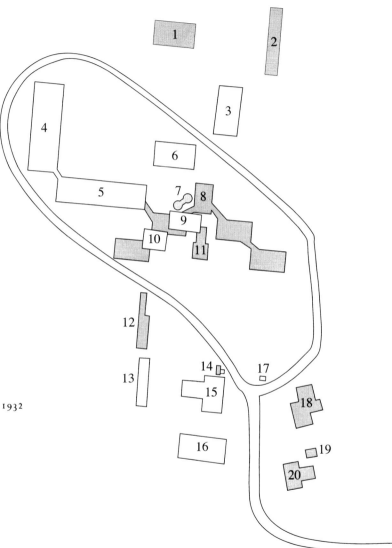

Last remaining asylum
cow barns #206 (*left*)
and #204 (*right*)

Photograph by
Heidi Johnson, 1999

COW STALL IN FORMER
CALF BARN #206

Photograph by
Heidi Johnson, 1998

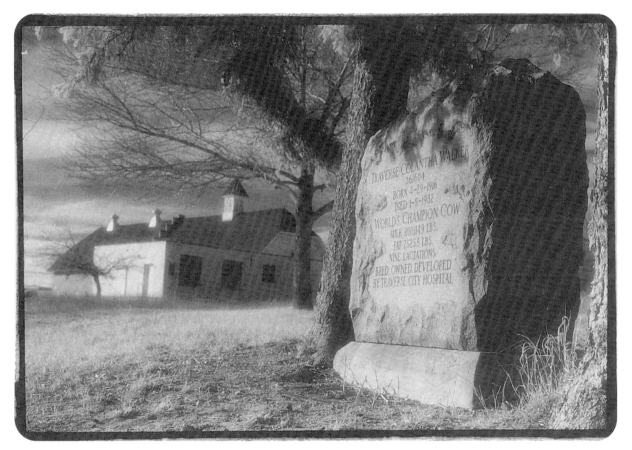

Tombstone of world champion dairy cow Traverse Colantha Walker, raised by asylum staff and patients, est. 1932

Photograph by Heidi Johnson, 1999

SISTER BLACK WILLOWS,
one a state of Michigan
champion tree. Both
stand near the asylum
barns on Silver Drive.

Photograph by
Heidi Johnson, 1999

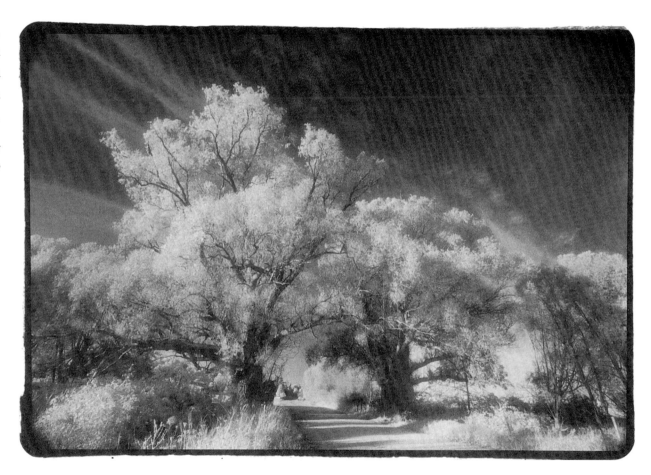

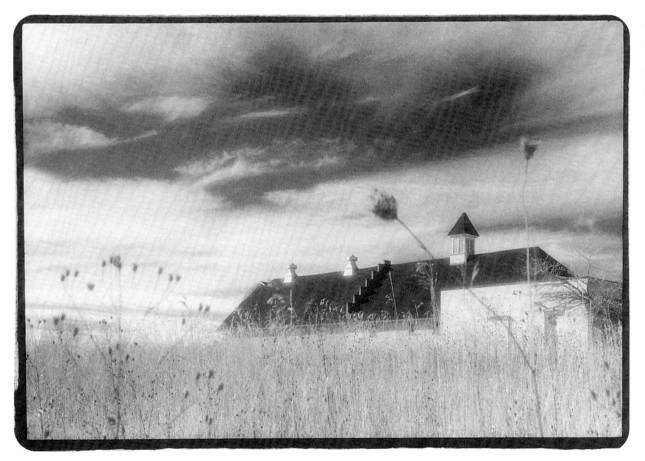

FIELDS VIEW,
former calf barn #206

Photograph by
Heidi Johnson, 1999

ORIGINAL COW BARNS, circa 1905. These cow barns were almost exclusively built of maple and basswood. They were used to house the large asylum dairy herds. The fenced-in area, shown here in the foreground, was the breeding pen. By the 1950s the barns were unused. Most were demolished by the state in the 1970s due to fire risk. After being demolished, the barn wood was burned in large bonfires by state hospital staff to avoid theft.

Courtesy of the Grand Traverse Pioneer and Historical Society

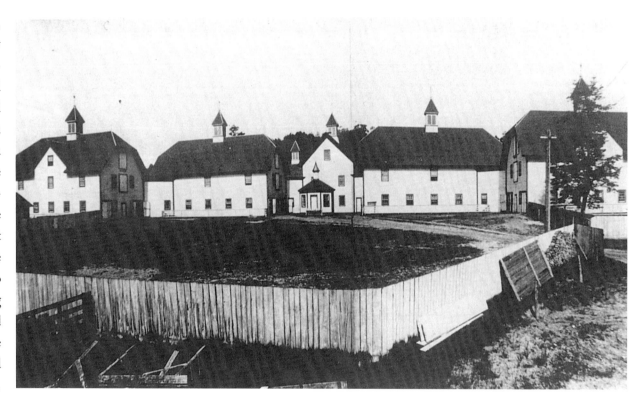

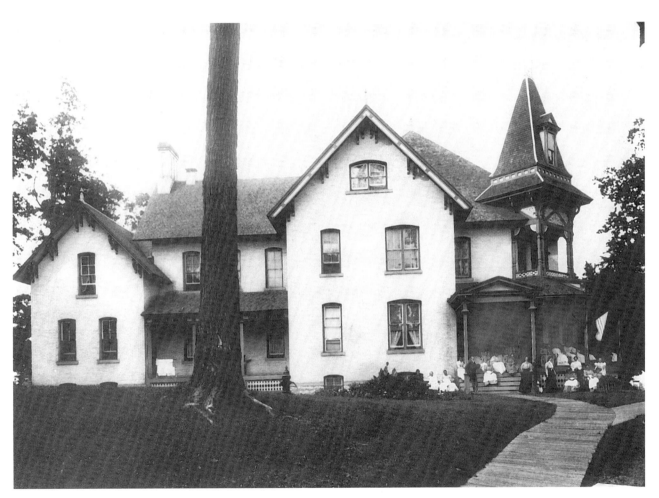

WOMEN'S COTTAGE 25,
circa 1895

Courtesy of the
Grand Traverse Pioneer
and Historical Society

WOMEN'S RECEIVING WARD
(a.k.a. Cottage 19),
circa 1912

Private collection of
Mary Rockwood

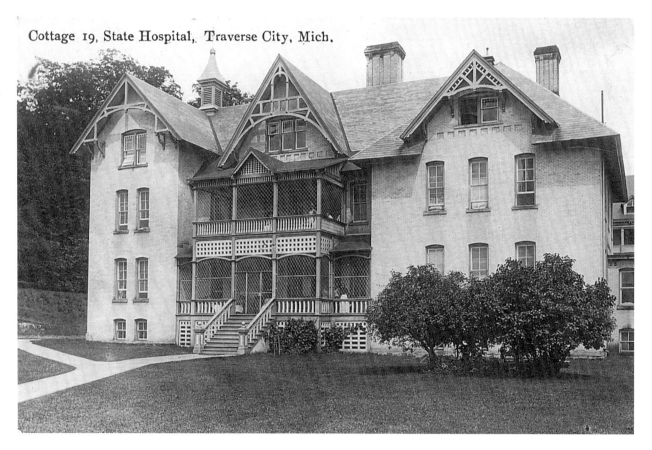

Cottage 19, State Hospital, Traverse City, Mich.

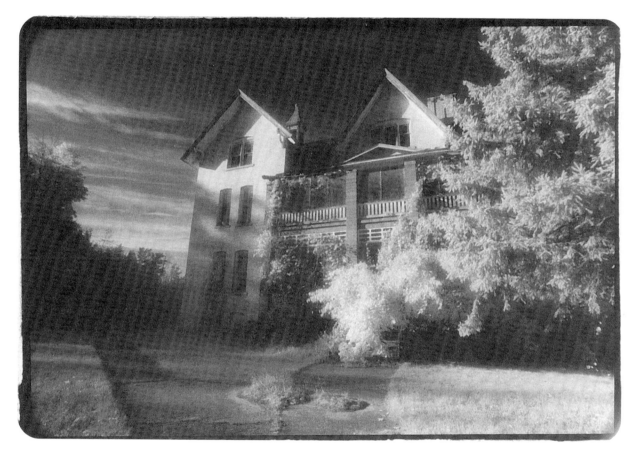

FORMER WOMEN'S
RECEIVING WARD
(a.k.a. Cottage 19)

Photograph by
Heidi Johnson, 1999

WOMEN'S COTTAGE 21,
circa 1920

Courtesy of the
Grand Traverse Pioneer
and Historical Society

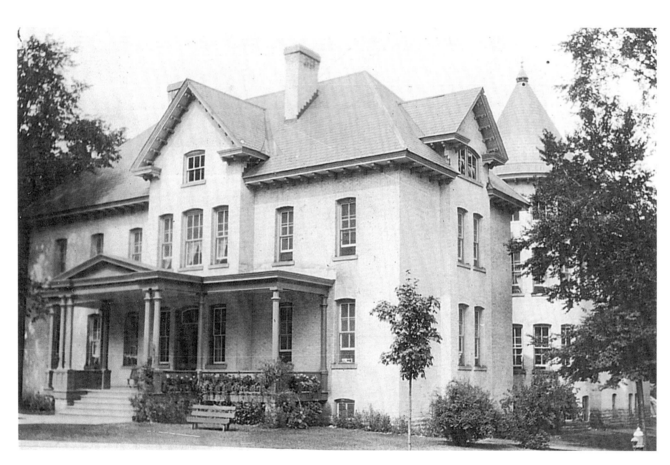

Nurse Attendants

Great pains have been taken to instruct the attendants in those principles which are deemed of the greatest importance in the care of the insane. The necessity for patience and kindness, for habit of close observation and for personal regard toward each person under their charge, has been especially dwelt upon. It has been said that the attendants are the eyes and hands of the physicians in the care of the insane, and the better the education and training they bring to the work, the greater the results to be expected from their labor. We trust the time is not far distant when all who wish to engage in this special work will have to fit themselves especially for it. A corps of educated and skillfully trained attendants is of great worth in the moral treatment of the insane. The benefit of the association of the attendant with the insane cannot be estimated. Words of cheer and acts of attention and interest have a large measure of influence, especially during the period of convalescence. The permanency of a good corps of attendants is of the greatest importance, and no effort should be spared to secure this permanency. Our attendants have reached a high standard of excellence, and have manifested an enthusiasm for their work which is highly commendable.

James Decker Munson, *Report of the Board of Trustees of the Northern Michigan Asylum at Traverse City,* September 30, 1886.

First nurse attendants,
Northern Michigan Asylum,
circa 1886

Courtesy State Archives
of Michigan

Opposite Page:

First graduates from the
Northern Michigan Asylum
Training School for Nurses,
circa 1908

Courtesy State Archives
of Michigan

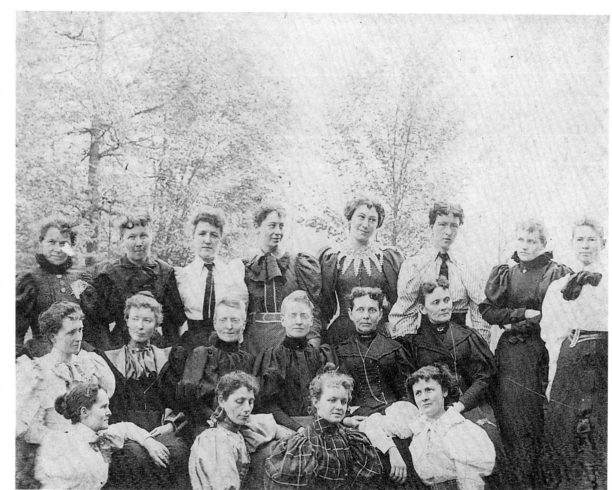

The Perfect Attendant

[The perfect attendant possessed] a pleasant expression of face, gentleness of tone, speech and manner, a fair amount of mental cultivation, imperturbable good temper, patience under the most trying provocation, coolness and courage in times of danger, cheerfulness without frivolity, industry, activity and fertility of resources in unexpected emergencies, [and the ability] to act as the guide and counsellor and friend of all the patients in their varying conditions.

Thomas Story Kirkbride, 1846

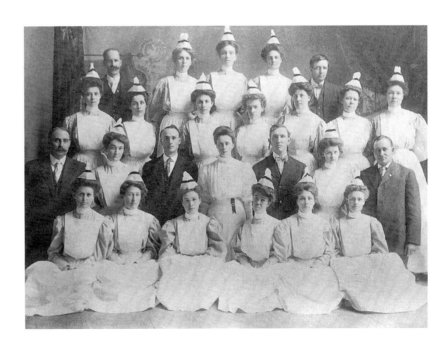

Eunice and Hattie Walsh, nurse attendants, Northern Michigan Asylum, circa 1886. Sisters Eunice and Hattie Walsh were both hired as attendants in 1885 to work in the brand-new Northern Michigan Asylum. Eunice (*left*), who had prior nursing experience, was paid $22 per month. Hattie, a nurse trainee, was paid $15 per month. Both sisters moved to the asylum campus in 1892 to live in employee housing and resided there for twenty years, until records of their employment ended in 1912. At that time, the sisters were earning $31 per month.

Courtesy State Archives of Michigan

Northern Michigan Asylum
Attendant Floor Nurse Duties—1886

1. Daily sweep and mop the floor of your ward; dust the patients' furniture and window sills.

2. Maintain an even temperature in your ward by bringing in a scuttle of coal for the day's business.

3. Light is important to observe the patients' condition. Therefore, each day fill kerosene lamps, clean chimneys, and trim wicks. Wash the windows once a week.

4. The nurse's notes are important in aiding the physician's work. Make your pens carefully; you may whittle nibs to your tastes.

5. Each nurse on day duty will report every day at 7 A.M and leave at 8 P.M. except on the Sabbath, on which day you will be off from noon to 2 P.M.

6. Graduate nurses in good standing with the Director of Nurses will be given an evening off for courting purposes, or two evenings a week if you go regularly to church.

7. Each nurse should lay aside from each payday a goodly sum of her earnings for her benefits during her declining years so that she will not become a burden. For example, if you earn $30 a month, you should set aside $15.

8. Any nurse who smokes, uses liquor in any form, gets her hair done at a beauty salon, or frequents dance halls will give the Director of Nurses good reason to suspect her worth, intentions and integrity.

9. The nurse who performs her labors and serves her patients and doctors without fault for five years will be given an increase of five cents a day, providing there are no hospital debts outstanding.

Nursing guidelines from 1886, Mental Health Museum (closed), Traverse City Regional Psychiatric Hospital.

UNKNOWN NURSE ATTENDANTS BY FERN,

Building 50, circa 1910

Courtesy of the Con Foster Museum

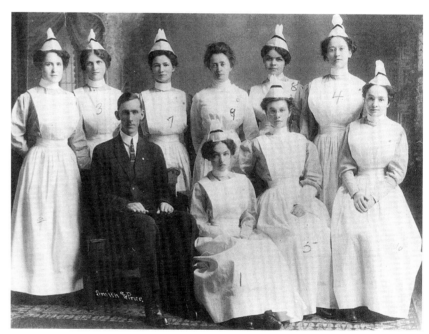

GRADUATE CLASS OF 1912,

Traverse City State Hospital Training School for Nurses

Courtesy State Archives of Michigan

GRADUATE CLASS OF 1937, Traverse City State Hospital
Training School for Nurses

Courtesy State Archives of Michigan

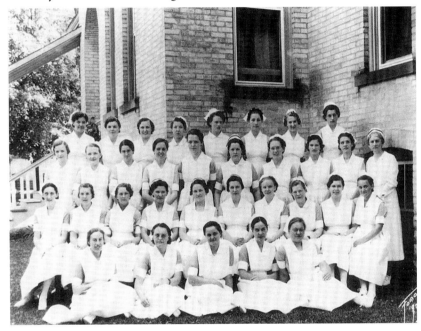

CLASS OF NURSES, circa 1965

Courtesy State Archives of Michigan

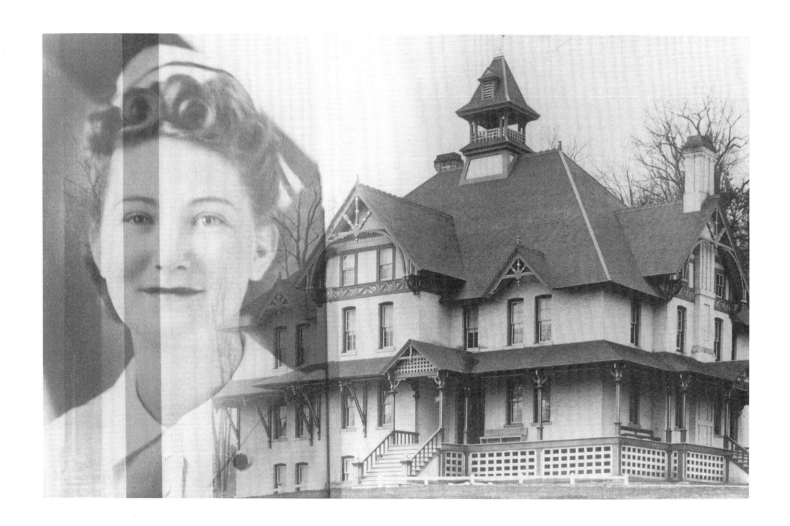

84

Miss Ruth Garn, age eighty, retired Traverse City State Hospital registered nurse, and Cottage 28

Photograph by Heidi Johnson, 1998

Opposite Page:

Miss Ruth Garn, age twenty-two, Traverse City State Hospital Nursing graduate, and men's Cottage 28, circa 1939

Courtesy State Archives of Michigan and Ruth Garn

Probable Exciting Causes

	Male	Female	Total
Abuse and cruelty	—	1	1
Bodily injury	—	1	1
Brain disease (apoplexy)	2	2	4
Business reverses	5	—	5
Congenital defect	4	3	7
Disappointed affections	2	1	3
Dissolute life	1	—	1
Domestic infelicity	3	17	20
Epilepsy	20	16	36
Eruptive fever	—	3	3
Fright	1	5	6
Grief, care, and anxiety	2	17	19
Ill health	17	25	42
Insolation	4	—	4
Intemperance	32	1	33
Nostalgia	1	—	1
Old age	5	4	9
Overwork and overstudy	2	3	5
Popular errors and dilusions	1	—	1
Previous attacks	2	1	3
Prolonged lactation	—	1	1
Pubescence	—	2	2
Puerperal	—	43	43
Religious excitement	3	2	5
Seduction	—	3	3
Sexual excesses	2	—	2
Shock	1	1	2
Syphilis	8	3	11
Traumatism (head injury)	5	—	5
Typhoid fever	1	1	2

	Male	Female	Total
Vicious habits and indulgences	55	4	59
Want and privation (poverty)	1	5	6
Unascertained	77	70	147
TOTAL	257	235	492

Complete loss of moral sense is rare even in the degenerate, yet there are individuals who, while showing no intellectual impairment are lacking in this sense. A patient 18 years old, was born in a county house. Her father was unknown; her mother died when she was five. Then she was sent, reason unknown, to the School for Girls at Adrian, where she remained until 16. She then returned to the poorhouse, and after a year went away with an old man and lived with him as his wife. Together they went to M. where the man was arrested. She then went with another man, who soon left her; and then with another, who also soon abandoned her. Then she began to work as a domestic, but she left her place of work and wandered about, resting in barns and deserted buildings where she was accustomed to receive the male public. She says she once burned a barn at the instigation of another. She has used whiskey. She never had hallucinations or delusions, and was never violent. Her life in the asylum has been quiet. She is cheerful and pleasant in manner, but will lie and steal. There has been since she came to the hospital a distinct moral improvement. When she first came she was perfectly self-satisfied, and seemed to have no respect for anything or anybody. Were she to leave her present surroundings and be thrown on her own resources, undoubtedly there would soon be a return to the former habits.

James Decker Munson, *Report of the Board of Trustees of the Northern Michigan Asylum at Traverse City,* June 30, 1892.

Men's convalescence
ward and dayroom,
Building 50, circa 1890

Courtesy of the
Grand Traverse Pioneer
and Historical Society

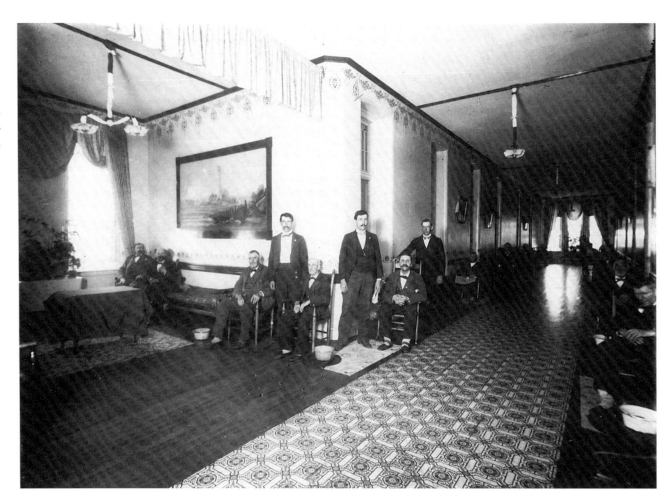

Removal of Patients to the Asylum

In conveying a patient to the Asylum do not deceive him. Truth should not be compromised by professing a visit to the Institution, and, on arrival, suggesting to the patient the idea of staying, when his admission has already been decided upon; nor should patients be induced to come and "stay a few days to see how they like it," under the impression that they can leave at pleasure. This course not only destroys confidence in friends, but also in the officers of the Asylum by giving patients an impression that they are parties to the deception.

Removal to the Asylum should never be attempted when the patient is much prostrated or laboring under severe bodily illness, and care should be taken that the excitement attending acute mental disease be not mistaken for physical strength.

*Report of the Board of Trustees of the Northern Michigan Asylum at Traverse City,
September 30, 1886.*

Patient Nativity

	Male	Female	Total
Austria	4	—	4
Canada	47	20	67
Connecticut	—	1	1
Denmark	3	4	7
England	13	14	27
Finland	8	4	12
Germany	30	30	60
Holland	3	1	4
Illinois	—	1	1
Indiana	1	3	4
Ireland	19	24	43
Italy	1	—	1
Maine	2	—	2
Massachusetts	—	1	1
Michigan	19	37	56
New Brunswick	1	1	2
Newfoundland	1	—	1
New Jersey	3	—	3
New York	28	28	56
Norway	7	5	12
Nova Scotia	3	—	3
Ohio	10	14	24
Pennsylvania	5	6	11
Poland	3	2	5
Russia	1	—	1
Scotland	5	2	7
Sweden	27	19	46
Switzerland	1	2	3
Tennessee	—	1	1

	Male	Female	Total
Vermont	—	1	1
Virginia	1	2	3
Wales	1	—	1
West Virginia	—	1	1
Wisconsin	4	4	8
Unascertained	6	7	13
Total	257	235	492

[This] table does not indicate the number of native born patients of foreign parentage. The number is undoubtedly quite large, but as it was often impossible to gain the information, any figures that could be furnished in this connection would be so lacking in accuracy as to be of no scientific value. Sixty-two and one-tenth per cent of the patients admitted were of foreign birth, and 37.9 per cent of native birth. The native born population of the Northern Asylum district was in 1880, 67 per cent, and furnished 37.9 per cent of the admissions, while the foreign born population was 33 per cent, and furnished 62.1 per cent of the admissions. This is certainly a very striking disproportion in the amount of insanity, whether an explanation is sought on the grounds of assisted emigration to this country of the defective classes, or in the fact that many coming to our shores "if not actually insane" are so enfeebled by hereditary influences, privation and want for successive generations, that "their nervous organizations become deranged from slight exciting causes." Foreigners coming to our country find new cares and responsibility, and many become depressed from lack of familiarity with our language and customs. Home-sickness is sometimes assigned as the cause of mental failure, but we may say that no case has been admitted where this was the only etiological factor. Some of the patients were insane previous to their emigration, but very few are known to have been deranged at the time of their departure for this country.

James Decker Munson, *Report of the Board of Trustees of the Northern Michigan Asylum at Traverse City,* September 30, 1886.

WOMEN'S
CONVALESCENCE WARD,
Building 50, circa 1895

Courtesy of the
Grand Traverse Pioneer
and Historical Society

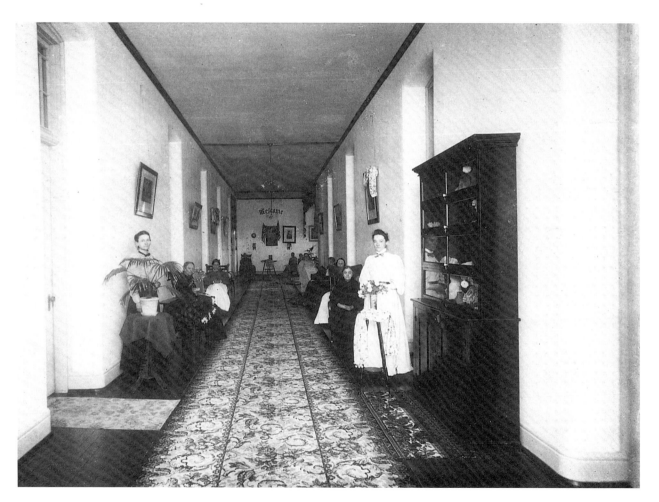

Patient Clothing

As friends of patients are often in doubt as to what articles of clothing it is necessary to provide, the following suggestions are made:

Male patients require 3 new shirts, 1 new and substantial coat and vest, 2 pairs pantaloons, 3 pairs socks, 2 pairs drawers, 2 undershirts, 1 hat or cap, 1 cravat, 3 collars, 6 handkerchiefs, 1 pair shoes or boots, 1 pair slippers, 1 overcoat.

Female patients should have 3 calico dresses, 3 chemises, 3 pairs drawers, 4 pairs hose, 3 night dresses, 3 cotton flannel skirts, 6 handkerchiefs, 4 collars, 1 pair shoes, 1 pair slippers, 1 shawl or cloak, 1 hat, hood, or nubia, 4 aprons.

The outfit should be liberal when circumstances permit. As nearly all the patients go regularly into the open air each day it is desirable that they be furnished with clothing of a character to enable them to go comfortably in all weathers, and also to appear at little social gatherings. When desired, articles of clothing, etc., will be furnished at the Institution. Jewelry should not be brought with patients. If such articles are left in their possession the Asylum cannot be responsible for their safe keeping.

Report of the Board of Trustees of the Northern Michigan Asylum at Traverse City, September 30, 1886.

VINTAGE POSTCARD,
circa 1900
(*Reverse side of
postcard seen on
opposite page*)

Private collection of
Heidi Johnson

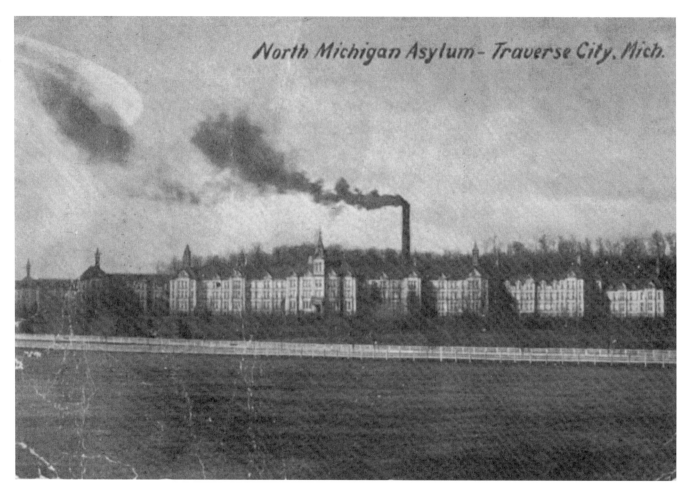

North Michigan Asylum - Traverse City, Mich.

Asylum Correspondence

All letters concerning patients, from individuals having the right to make inquiry, will be answered at once; and friends are promptly advised of any severe illness, accident, or event of moment or interest. The postoffice and telegraphic addresses of one correspondent in each case are recorded, to whom such communications are sent. Letters are frequently received to which replies cannot be mailed, for the reason that the postoffice address is not clearly given. A little care on the part of friends will often save them disappointment and the Asylum unmerited censure. Information concerning inmates will not be given to casual visitors, except at the written request of friends.

Report of the Board of Trustees of the Northern Michigan Asylum
at Traverse City, September 30, 1886.

A Traveler's Tale

In June 1892, Dr. James Decker Munson recorded this account of a patient's autobiography. In Munson's opinion, this patient was suffering from "degenerate insanity." In his report, Munson wrote his observations concerning this specific illness: "Unusual precocity has not been often noted in degenerates coming under our observation. As a class they learn well to a certain time, after which they show no special aptitude for instruction, and often in obedience to vague impulses, wander from place to place and from occupation to occupation. This tendency has been very frequently observed, and the following is given as a most interesting example:"

C. W. D., male, aged 36, was admitted May 18, 1891. History stated that he had simply been wandering about, and people were afraid of him. The day following admission he had a light convulsion, there being no premonitory symptoms. The effects of the convulsion passed away in a few moments. From this time on he was a very pleasant patient, causing no particular trouble. After being confined a month he was discharged. The following is a brief outline of an autobiography of the patient:

———◆–◆–◆———

I was born in 1855. A few years later my father died, and at the age of nine years I was sent to a reform school because of an innate tendency to steal anything and everything I could get hold of, whether it was of any value to me or not. I escaped from the reform school by tunneling underneath the surrounding walls, and at the age of eleven had been adjudged insane and sent to S. G. asylum. Right here I might say that I have had convulsions since I was six months old, brought about, it was thought, by an injury received by being dropped from my sister's arms upon the sidewalk at that age.

At 13 I was removed from the S. G. institution by my brother and placed in an Asylum. After a year's confinement I escaped, but was soon arrested for vagrancy and petty thefts and sent to the workhouse at W. I served my time, and then went to Detroit, Mich., and entered the service of the U.S. navy. After two years

of service I was discharged because of lack of ability to do my work. From Detroit I went to Buffalo, then to Utica, where I was again arrested and sent to the asylum. Here I remained three months, and was discharged and sent to New York city. My love for liquor again brought trouble, and I was sent to Blackwell's Island for 90 days. Here my mental condition was ascertained, and I was transferred to the Long Island asylum. After three months of confinement I escaped and went to Philadelphia, Pa., where I secured employment on an oyster dredge in Chesapeake bay. In six months my services were dispensed with, and I shipped on Str. Dongola for San Francisco, Cal. I arrived in that city at the age of 16, was immediately discharged, and before being on land a day I was arrested and sent to an asylum. My discharge followed in three months, and I started by rail for Cedar Rapids, Ia., but drink again put me in an asylum at that place. In six months I was released and sent to Burlington. I next worked on a farm for some time, going on an occasional drunk. This mode of living became too monotonous, and I started for Chicago, but liquor again stopped me in an asylum. At the expiration of the usual period of confinement (six months) I was released and went to Chicago, and soon found myself at the workhouse, as a result of obtaining money under false pretenses. At the expiration of my sentence I shipped on board the Str. Gordon Campbell for Detroit, where I secured employment; but the intense heat, together with an unlimited amount of whisky, completely prostrated me and I was sent to a hospital, where I was under medical treatment for four months. After my discharge I went to New York city and shipped for Liverpool. On our arrival in England I was sent to an asylum, until there was an opportunity to return me to America. On my return I was sent to government hospital. After I was discharged I started for Iowa, but hired out to an Ohio farmer for whom I worked faithfully for one year. At the expiration of that time I went to T., Ohio, with $140 in my pocket, expecting to have a good time, but I was soon committed to the C. asylum. It was one year before I was considered able to care for myself, and immediately on my discharge I went to Baltimore, thence to Charleston, near which place I worked on a farm for two months, and was then married. Through my wife I came into possession of a farm and $1,000 cash. For six months everything went nicely, then my wife dying, took to drink, left home, secured employment at Chesapeake Bay for a time. I next went to Chicago, shipped to Buffalo, served four months' time at Buffalo workhouse, and then proceeded to New York city, but again returned to Buffalo and shipped to Bayfield, Wis.

My desire for liquor again prevailed and I soon found myself at the Oshkosh asylum, where I remained for 18 months. After my discharge I went to M., and was again committed to an asylum. I escaped, went to Chicago, thence to New York city, back again to Wisconsin, and was sent again to Oshkosh asylum. After a stay of two months I escaped, went to Chicago, shipped for Detroit, where I passed the winter. The following spring I went to Toledo, shipped for Chicago, and on arriving at that city, went ashore, got drunk, was discharged, and immediately started by rail for Ludington, Mich., but was arrested at Niles and sent to Ionia prison and later was transferred to Ionia asylum. On my release, which occurred in a year, I started for Ludington a second time, but was arrested for drunkenness in Reed City and sent to Ionia again. I served my time and made a third start for Ludington. Reaching this place at last, I secured employment on a lake steamer, but was finally put ashore in Muskegon, and then committed to Pontiac asylum. Four months later I was in the government hospital, and after nine months' rest returned to Chicago and worked on a steamer between Grand Haven and Chicago. Began drinking again, and this time was committed to Michigan Asylum at Kalamazoo. Five months later I was discharged. After a short visit among relatives I started for Harrisburg, but before reaching my destination I was arrested and sent to Harrisburg Asylum. Was confined a month, and then went to Baltimore, and from thence to Chicago, where I shipped to Ashland, Wis. At the latter place I was discharged, went to Wisconsin Junction, and the convulsions recurring, I was sent to Oshkosh Asylum again for the third time. In three months went to Milwaukee, began drinking, was sent to workhouse for 60 days. After serving my time I left for the East, and at Erie, Pa., shipped for Duluth. Our vessel was run into off Whitefish Point and sunk, two of the crew perishing. After spending three days in a life boat, I was taken aboard a steamer, which landed me in Chicago. From here I went to Baltimore, was taken ill and spent some time in city hospital. I then worked my way back to Menominee county, Mich., and was engaged in a lumber camp for five months. Later I visited Traverse City, was promptly arrested for drunkenness, fined, and ordered to leave town. Went to E., got drunk, wandered in woods eleven days, and returning to M., was committed to Northern Michigan Asylum.

Report of the Board of Trustees of the Northern Michigan Asylum at Traverse City, June 30, 1892.

A Curative Lost

One of the most vivid recollections of my childhood was the spectacle of a refined looking young woman going about the country in the winter time, thinly clad, carrying in her arms two cornstalks, which she called her children. She was a case of puerperal mania who had once been curable, but through neglect and the lack of provision for her curative treatment had become hopelessly insane. A few days since I saw a newspaper paragraph containing her name as the resident of a county poorhouse in the southern part of the state, where she was living at an advanced age. How many years of hopeless misery might have been averted had this poor woman received curative treatment at the proper time! I also recall many cases of harmless dementia who wandered restlessly about the country. They were known as "fools." Among the number I can remember "Smith's fool," "Gates' fool" and "Olin's fool." They were a great terror to young children and defenseless females. It was considered a good joke to send them about from one farmhouse to another, especially in the night, or to frighten them away when they came as unwelcome guests at midnight. Two, at least, of these "fools," as they were called, I remember to have perished in burning barns where they had sought shelter at night from failure to secure other accommodations.

Henry M. Hurd, first medical superintendent of the Eastern Michigan Asylum in Pontiac. From a paper presented in 1888.

Occupations

	Male	Female	Total
Accountant	—	2	2
Baker	1	—	1
Blacksmith	7	2	9
Bookbinder	1	—	1
Butcher	2	—	2
Carpenter	2	6	8
Chairmaker	1	—	1
Clerk	2	—	2
Collier	1	—	1
Cook	1	1	2
Cooper	—	1	1
Copper smelter	1	—	1
Domestic	—	26	26
Dressmaker	—	1	1
Engineer	3	3	6
Farmer	59	51	110
Fireman	2	1	3
Fisherman	1	—	1
Gardener	1	—	1
Goldsmith	1	—	1
Harnessmaker	—	3	3
Housekeeper	—	28	28
Iron moulder	2	—	2
Laborer	120	42	162
Liveryman	1	—	1
Lumberman	2	4	6
Machinist	1	2	3
Mason	3	1	4
Mechanic	—	1	1
Merchant	1	2	3

	Male	Female	Total
Millwright	1	—	1
Miner	14	11	25
Minister	—	3	3
Nurse	—	1	1
Physician	3	1	4
Railroad employee	1	—	1
Sailor	—	1	1
Saloon-keeper	2	3	5
Saw-filer	—	1	1
Shoemaker	1	1	2
Soldier	—	1	1
Tailor	1	3	4
Teacher	—	4	4
Trapper	1	—	1
Weaver	—	2	2
Unascertained	13	16	29
None	5	9	14
TOTAL	257	235	492

An occupation properly pursued as an occupation can scarcely be considered a cause of insanity. As the table shows, laborers and those employed in the least remunerative occupations furnish the largest proportion of patients. Here the inseparable conditions are overwork, privations, malnutrition, oftentimes intemperance, ill-health, and the miseries attendant upon it, all of which directly favor the development of nervous disorders.

James Decker Munson, *Report of the Board of Trustees of the Northern Michigan Asylum at Traverse City, September 30, 1886.*

Age of Patients

	Male	Female	Total
15 years and under	3	—	3
16 to 20	8	9	17
21 to 25	25	17	42
26 to 30	38	29	67
31 to 35	34	32	66
36 to 40	42	36	78
41 to 45	37	35	72
46 to 50	16	27	43
51 to 55	13	17	30
56 to 60	12	9	21
61 to 70	11	11	22
71 and upward	6	3	9
Unascertained	12	10	22
TOTAL	257	235	492

[This] table is of interest, as it shows that the age of greatest liability to insanity is from 25 to 45. It also demonstrates that no period of life is exempt from mental disease from youth to old age. Youth is not especially prone to insanity, but from faulty training, vicious courses and associations the seeds are often sown which have for a heritage mental deterioration. A glance at the table of probable exciting causes will show the certain habits once formed are most disastrous to the "healthy evolution of the mental faculties." The period of life between 25 and 45 brings its special difficulties and temptations. "The weakly principled and ill-balanced fall victims in the combat between passion and principle, and among the various deplorable issues an attack of maniacal excitement is one." Business activity is at its height, and the struggle for competency with its successes and failures, its pleasures and anxieties, each year cause some to fall by the wayside. Beyond the age of 50 loss of family and property, and the impairment of physiological adjustment between nerve stimulation and nerve nutrition, may lead to dethronement of reason.

James Decker Munson, *Report of the Board of Trustees of the Northern Michigan Asylum at Traverse City, September 30, 1886.*

Accounts of the First Twenty Patient Deaths,

November 30, 1885–September 30, 1886

The death rate has been low, considering that all classes of cases, without regard to age or physical condition, have been treated. To remove an aged and feeble insane person from long accustomed surroundings to the asylum is frequently of itself sufficient to induce fatal exhaustion. I believe great circumspection should be exercised before committing aged people to our institutions. All methods for their care at home should, at least, be exhausted before such a course is resorted to. . . . Twelve males and eight females have died during the period.

James Decker Munson, *Report of the Board of Trustees of the Northern Michigan Asylum at Traverse City, September 30, 1886.*

Male, age 45, married, native of Germany
Occupation: saloon keeper

"When admitted he was far advanced in general paralysis. He was greatly demented, but entertained extravagant delusions of his own wealth and personal importance. He had several paralytic seizures, the last on January 2, 1886. He became profoundly comatose, and never regained but partial consciousness after its occurrence. The only unusual symptoms he presented were a profuse perspiration which was reddish in color, the rapid development of an abscess in the right knee and a purulent inflammation of the bladder. He was unable to assimilate food, and died fourteen days after the seizure."

Died: January 12, 1886
Cause of death: general paralysis

Female, age 64, married, native of Ireland
Occupation: farmer's wife

"She came to the institution in impaired mental and physical health. From the first she complained of a series of indefinite and obscure symptoms, the most prominent of which were obstinate constipation and abdominal tenderness. There was some distension of the abdomen, but this did not become a marked symptom until late in January, 1886, at which time it suddenly increased to such an extent as to interfere with easy respiration. A little later she exhibited symptoms of severe shock. She grew rapidly worse and died three days later. The autopsy showed that the upper portion of the rectum was the seat of cancerous degeneration, which had ulcerated and led to intestinal perforation."

Died: February 2, 1886
Cause of Death: cancer

Male, age 37, married, native of Michigan
Occupation: farmer

"He died very suddenly from a paralytic seizure"

Died: February 22, 1886
Cause of Death: general paralysis

Male, age 40, single, native of Germany
Occupation: farmer

"After a severe convulsion he became comatose, a condition from which he never rallied."

Died: March 10, 1886
Cause of Death: general paralysis

Male, age 44, married, native of England
Occupation: miner

"[He] had suffered from general paralysis two years previous to his admission to the asylum. His death was due to a paretic seizure."

Died: March 12, 1886
Cause of Death: general paresis

Female, age 27, married, native of Michigan
Occupation: fisherman's wife

"[She] was so much paralyzed when admitted as to be unable to walk. She presented many of the symptoms of general paralysis, and finally died from exhaustion incident to a paretic seizure. This case was interesting, from the fact that general paralysis is rarely seen in a female, and that the disease had its origin in the cord, the brain becoming involved secondarily. The autopsy revealed very marked changes in the cord and brain."

Died: March 20, 1886
Cause of Death: general paralysis

Male, age 27, single, native of Ireland
Occupation: laborer

"[He] was, when admitted, much demented, and in delicate physical health. His death was due to acute peritonitis, caused undoubtedly by his degraded habit of eating irritating and indigestible articles. Broom straws, the nap from the blankets, articles from the spittoons, and other filthy and disgusting material were to him choice morsels."

Died: April 11, 1886
Cause of Death: acute peritonitis

Male, age 42, single, native of Germany
Occupation: laborer

"When admitted he was suffering from dementia and advanced pulmonary disease. He presented the usual symptoms of phthisis, and died at the end of four months. The post mortem examination showed that both lungs were the seat of extensive tubercular degeneration."

Died: April 19, 1886
Cause of Death: phthisis

Male, age 65, married, native of Germany
Occupation: farmer

"[He] was extremely demented when he came to the institution. He suffered from an attack of acute peritonitis, and died in a few days after its onset. The autopsy revealed that prior to this attack there had probably been long standing sub-acute peritoneal inflammation. The lower lobe of the right lung was also found to be inflamed."

Died: May 4, 1886
Cause of Death: pneumonia

Male, age 43, married, native of Sweden
Occupation: farmer

"[He] was brought to the asylum in a dying condition. He was suffering from acute delirious mania, and extremely exhausted from excitement and abstinence from food. In spite of every effort to sustain him he sank into a coma, and died 72 hours after his admission. We may say in this connection that patients who are delicate or have refused food for some time should not be removed to an asylum without a statement from the attending physician that they are physically able to endure the journey."

Died: June 11, 1886
Cause of Death: delirium grave

Male, age 80, married, native of New York
Occupation: farmer

"[He] was brought to the institution in the last stages of Bright's disease. He was dropsical, and suffered dyspnoea to such an extent that he could not lie down. He gradually failed, and died 14 days after his admission."

Died: June 20, 1886
Cause of Death: Bright's disease

Male, age 76, married, native of Michigan
Occupation: laborer

"[He] was never fully conscious after he came to the asylum. He gradually sank into coma, and died 14 days after his admission. He probably suffered from meningeal hemorrhage."

Died: June 30, 1886
Cause of Death: meningeal hemorrhage

Female, age 48, married, native of Germany
Occupation: farmer's wife

"[She] suffered from pulmonary consumption. The autopsy showed almost complete tuberculous wasting of the lungs."

Died: July 20, 1886
Cause of Death: phthisis

Female, age 41, married, native of Pennsylvania
Occupation: farmer's wife

"[She] was admitted to the institution suffering from acute mania. She died very suddenly from apoplexy two weeks after admission."

Died: July 30, 1886
Cause of Death: apoplexy

Female, age 42, married, native of Tennessee
Occupation: none

"[She] was admitted to the asylum suffering from syphilitic insanity. She soon after had an attack of right-sided hemiphlegia, from which she never recovered. She died from exhaustion about three months after the onset of the paralysis. The autopsy revealed a large clot in the midst of the left hemisphere of the brain, which involved the lenticular nucleus, the internal capsule, and a portion of the optic thalmus. It may be of professional interest to state that she was after the attack hemianaesthetic."

Died: August 14, 1886
Cause of Death: apoplexy

Female, age 36, single, native of Michigan
Occupation: domestic

"[She] was admitted to the institution in very delicate bodily health. Her mind was greatly impaired. She was extremely bronzed, and Addison's disease was suspected. Her lungs were also found to be diseased. She only lived a few weeks. The autopsy revealed tubercular degeneration of the lungs, enlargement of the liver, atrophy of the right kidney, and extreme wasting of the suprarenal capsules."

Died: August 25, 1886
Cause of Death: tuberculosis

Male, age 29, single, native of Finland
Occupation: laborer

"[He] was admitted to the asylum suffering from delusions of suspicion. It was found that he had tuberculosis. The disease ran its usual course. The post mortem verified the diagnosis. The lungs were extremely diseased."

Died: August 26, 1886
Cause of Death: tuberculosis

Female, age 80, married, native of Pennsylvania
Occupation: none

"[She] was admitted to the asylum suffering from senile dementia. She died a few months after. No cause for her death can be assigned other than old age, as she presented no sign of acute disease."

Died: September 2, 1886
Cause of Death: senility

Female, age 71, married, native of Massachusetts
Occupation: minister's wife

"[She] was admitted to the asylum suffering from chronic dementia. She had extensive lung disease. She gradually failed, and died from pulmonary consumption."

Died: September 15, 1886
Cause of Death: pulmonary consumption

Male, age 46, married, native of Germany
Occupation: gardener

"[He] was admitted to the asylum well advanced in general paralysis. His death was due to exhaustion incident to a paretic seizure."

Died: September 19, 1886
Cause of Death: general paralysis

James Decker Munson, *Report of the Board of Trustees of the Northern Michigan Asylum at Traverse City, September 30, 1886*, and the State of Michigan, Record of Deaths at the Northern Michigan Asylum, 1885–86.

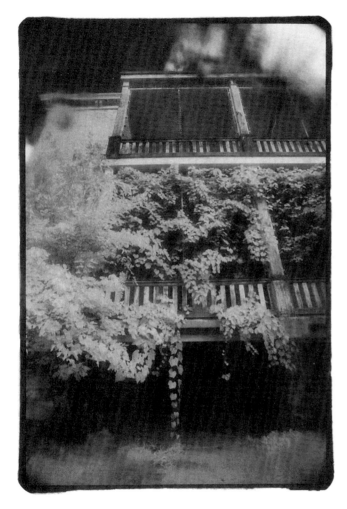

Vines over porches,
women's ward, Building 50

Photograph by
Heidi Johnson, 1999

Where there is sorrow there is holy ground.

Oscar Wilde, *De Profundis*

YELLOW ROOM, men's ward,
Building 50

Photograph by
Heidi Johnson, 2000

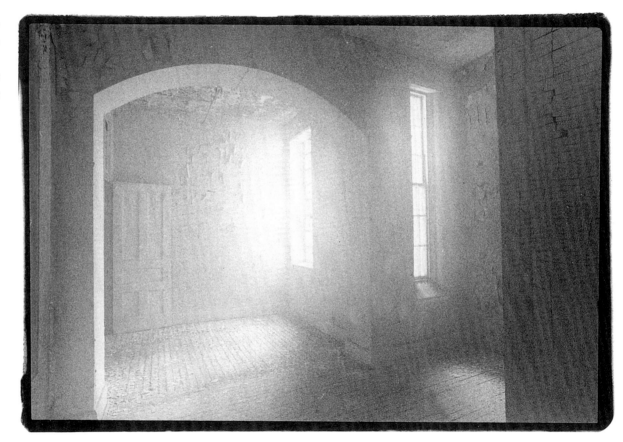

Old, abandoned rooms
still with the presence
of those inhabiting them.
These spirits once
people, people many times
with much more insight
than the rest
Doomed to live a life
titled with shame
Labeled "different."

The contrasts between
now and then
at first seem great,
realizing only now
how those rooms
must have appeared
to those who called
them home.

Walking the grounds,
they still seem
to roam
wondering,
waiting,
watching the world
pass by leaving
them behind.

They are those
who are
angels now
and add grace
and beauty captured
now in medium of
subtle greys and shadow.

Poem left anonymously in the *Angels in the Architecture* photographic exhibit journal, May 1998.

ISOLATION ROOM #16,
women's ward, Building 50

Photograph by
Heidi Johnson, 1998

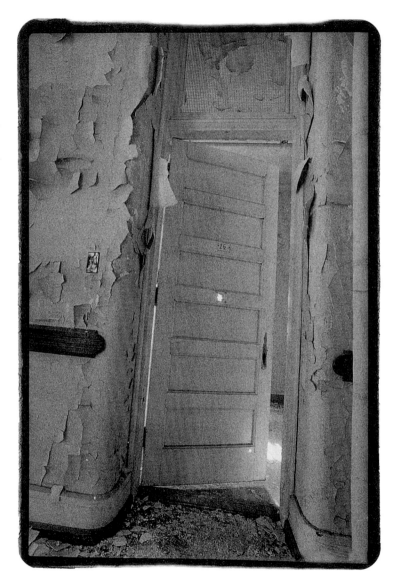

Deliverance

Her room was a "blind" room . . . made of concrete . . . an iron bedstead bolted to the floor . . . on it a thin, untidy looking mattress and a remnant of an old black woolen blanket. Near the high ceiling was a small window . . . also a narrow transom window over her door. Very little light could find its way into this room which served as a bedroom, dining room, toilet and sitting room . . . day in and day out, month after month.

Occasionally groups of attendants would take her to the toilet or give her a tub bath, never as often as needed.

My friend, of the same church affiliation as I, on this day was clothed in a coarse white State nightgown and sitting on her bed which was the only piece of furniture in her room. As I opened the door and spoke to her she looked at me and asked, "Sister Garn, do you think God could hear a prayer from a place like this?" Had I not been well indoctrinated in my belief in the omnipresence of God I could well have questioned it myself. The stench of years of rough concrete floors and walls saturated with body waste was overpowering, although the room itself was scrubbed clean. The gloom of a dark room, the total absence of any comfort item . . . even a magazine . . . and the surrounding disturbing voices of irrational noisy people, many of them, like herself, kept locked in a room, did nothing to make even the Almighty seem accessible. "Do you think God could hear a prayer from a place like this?"

"Yes, I know He could. He can hear a prayer from right here." I tried to encourage her, locked the door and went my way . . . sad because of the hopelessness of her case. The doctors had told her husband . . . and he had come to me to discuss his discouragement over the fact that there was no hope . . . and of his own loneliness. . . . She had been there a long time.

Within a few days, making a ward visit in another part of the hospital on a quiet home-like ward, there was a cry of joy as I entered the long hall and my friend came running to me saying, "Oh, Sister Garn, The Lord healed me . . . and I'm going home!" What a beautiful surprise! Not only to the disciples, but often to such as I, The Master must say, "Oh, Ye of little faith, Why do you doubt."

She went home to her family many years ago and to my knowledge has never had to re-enter a psychiatric hospital.

From the journal of Donna Garn Pillars, former assistant director of nursing, Traverse City State Hospital, 1928–74.

Opposite Page:

"ANGELS IN THE ARCHITECTURE," women's "most disturbed" wards 5, 11, and 17, Building 50

Photograph by
Heidi Johnson, 1998

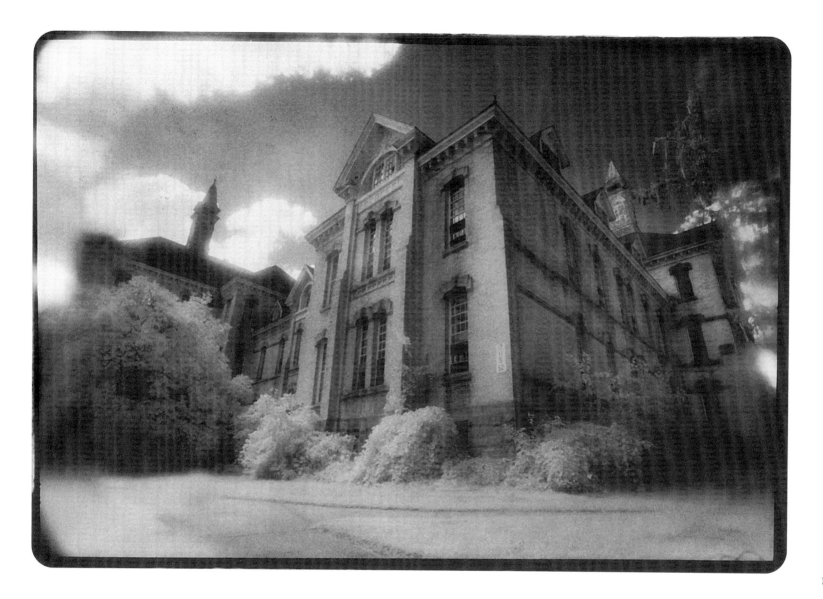

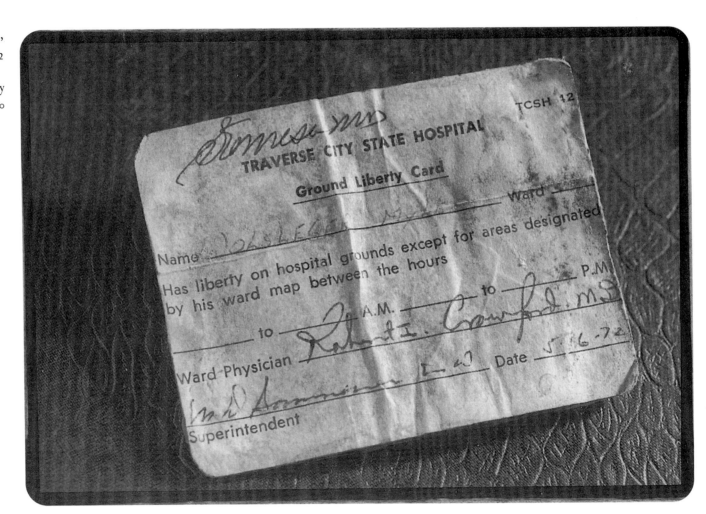

A Day in Building 50

You ask what a day was like in Building 50. Well, you got up at 6 A.M. to get ready to be told when to go to the dining room to eat. In fact, you didn't have a choice as to whether you wanted to eat or not. You were told you had to. Then when everyone one was told they were done eating, you left and waited for the door to be unlocked, so you could go back and line up for your meds. Again, no choice. If you refused to take any of your meds, you were put in seclusion until they could force you to take your meds. I was there a few times myself as I did not like what Haldol did to me, but I had to take it. That was the way things went back then. There was some staff who didn't give a damn and treated you like shit. I remember one nurse who told me if I just went along with what they said, it would be easier on me in the long run and I would not have so many shock treatments or be put in seclusion.

After they gave out meds, they would have therapy sessions—as they were called. You could not say much there for fear of being punished. Then you were told when to eat lunch. You would line up like little kids who didn't know anything, and then more meds. Later in the day, you might have a caseworker come to see you, or you would just roam around the dayroom to have a smoke or two if you were lucky enough to have your own smokes. You could have as many as you wanted, but if the state gave you cigarettes, you could only have one every odd hour. A lot of people would keep asking you for a cigarette. There were many fights over that and then you would get put in seclusion and given some kind of shot that would knock you out so you would calm down and not be a problem to the staff. . . . I ended up staying by myself and not doing much more than I had to. To get by, I started watching a lot of TV, whether I liked what was on or not, just to save myself from getting into a fight or going to seclusion.

I finally got a ground pass this way. I was able to go for walks on the grounds and go to the canteen for a coke and a good snack. I was able to go to bingo and win cigarettes, and sometimes they would come around and give us a couple packs. Sometimes they would have dances and again give us cigarettes. So if you were to

earn a ground pass, you got to do more things. I never got a town pass, but I did work my way out of Building 50 a few times.

When I was there, I felt like we were treated like a herd of cows or something like that. We were told what we could and couldn't do; when to sleep and when to get up. To this day, I don't like to be asked or told what I can and cannot do. I get angry all over again, but even that is getting somewhat better. I hope you can use some of this, and if you can't then I am sorry, but that was how it was for me. It was not all it was cracked up to be. In the 1960s, it was not a place of concern or compassion for the good of the people, unless you stayed by yourself and did not give the staff any problems.

Elizabeth, former patient, interview, 1999

Opposite Page:

ASYLUM BUTTER KNIFE,
circa 1910

Photograph by
Heidi Johnson, 1998

ORNATE DOOR HARDWARE,
in former patient
library/chapel area,
Building 50

Photograph by
Heidi Johnson, 1997

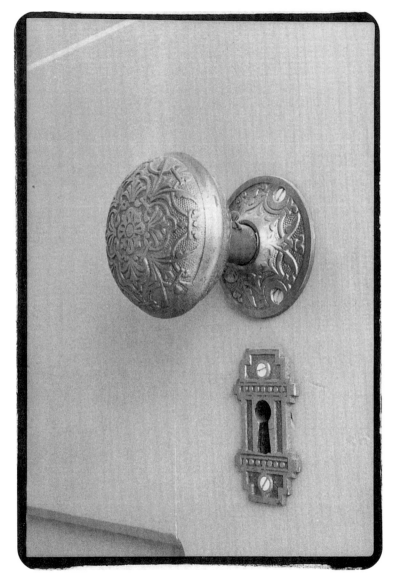

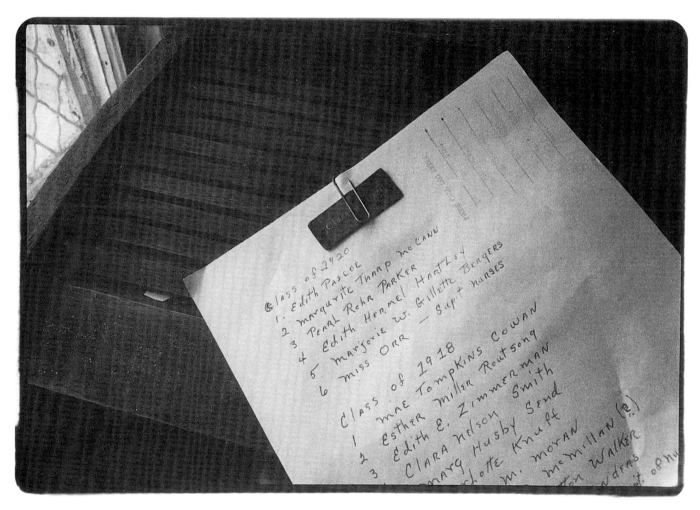

123

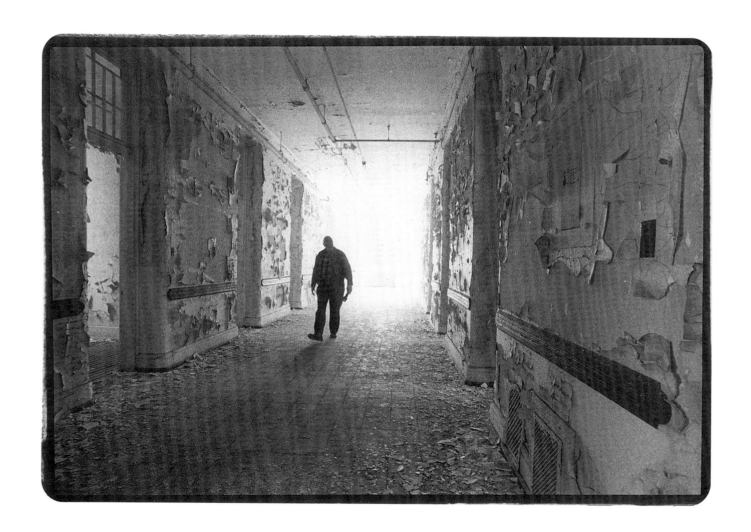

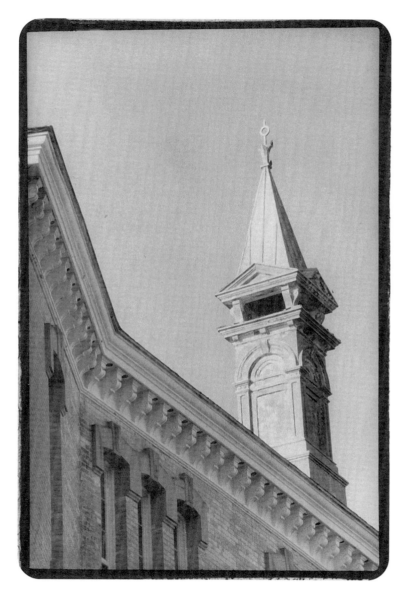

Spire over women's ward,
Building 50

Photograph by
Heidi Johnson, 1998

Opposite Page:

"Ralph," retired Building 50
maintenance supervisor,
men's ward, Building 50

Photograph by
Heidi Johnson, 1997

125

ROOM 23, women's ward,
Building 50

Photograph by
Heidi Johnson, 1997

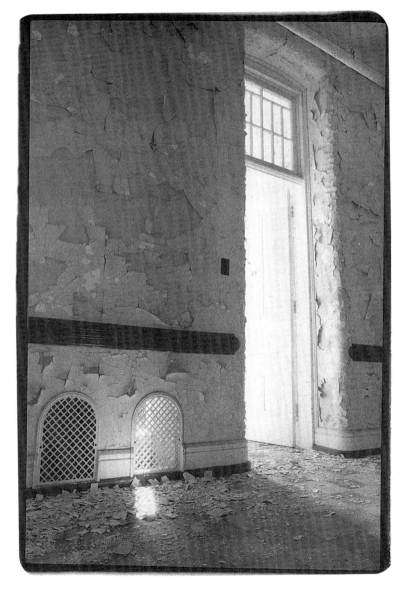

A Simple Glass of Juice

There was a patient who came in very depressed. She wouldn't drink, and she wouldn't eat. She was getting very dehydrated, and we began watching her twenty-four hours a day. We did the watch under "one to one" supervision—we also called it "specialing."—All of us would take turns and "special" one or two hours with her. Someone was usually just across the hall from her room or somewhere where they could see her directly. Some of the nurses could be a bit standoffish, but I was never like that, I always tried to connect with the patients. One day, just before it was my turn to watch her, I realized I was thirsty and went to get some juice. I decided to bring a juice back for her. Well, when I offered it to her, she would have no part of it. I'm sure she thought there was medicine in the juice and that I was trying to trick her. She refused it flat out. So calmly, I just sat down on the mattress beside her. (There was only a mattress on the floor, because in the seclusion rooms beds were considered too dangerous.) Anyway, I just sat down on the mattress beside her, put my back up against the wall and watched her watching me. She was a big gal, and I said quietly, "I've got two glasses of juice here, and I'm thirsty, and I want one. You tell me which one I can have, and if you want the other one, there it is." She didn't speak but after a moment slowly picked a cup off the tray and handed it to me. I brought it to my lips and drank it all down straightaway. Pretty soon she picked up the other juice and drank it all, too. Weeks went by and eventually she got better and left. But before she left, she came to me one day and said, "You know, you saved my life that day. . . . I was in such a hell. . . . I didn't trust anyone, and I just knew when you came in it was different. You didn't sit in a chair across the hall. You came in and sat down beside me and made me feel I was a real person." To this day, I will never forget her and the power of a simple glass of juice.

Recollection by Bonnie Witkop Hajek, former nurse attendant,
Traverse City State Hospital, 1965–89.

NINE WINDOWS,
men's ward 8,
Building 50

Photograph by
Heidi Johnson, 1997

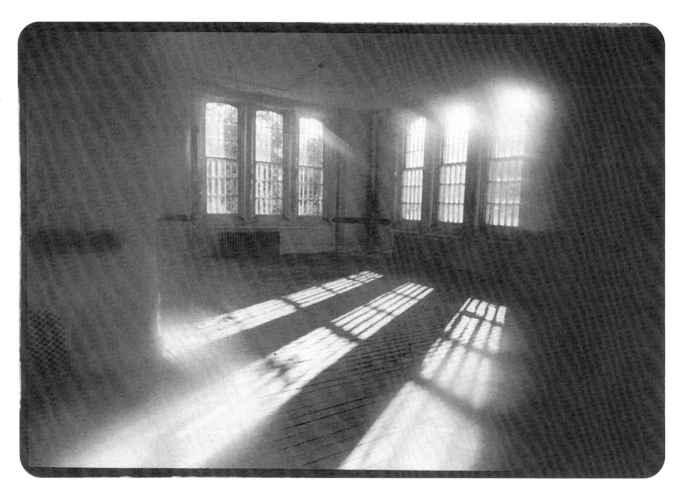

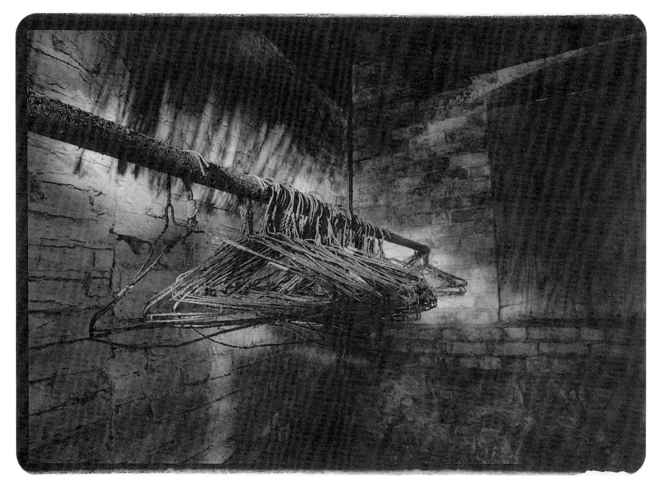

RUSTED HANGERS
IN TUNNEL ROOM
UNDER BUILDING 50

Photograph by
Heidi Johnson, 1998

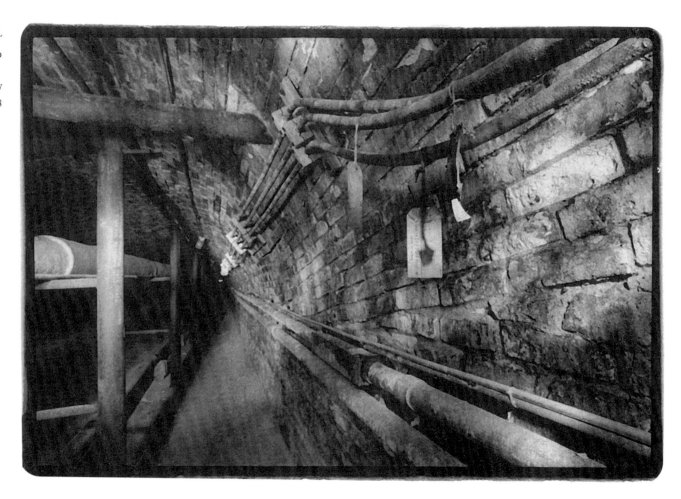

Warning in the Tunnel

My evening tour of a section of out-lying cottages and wards was completed. I was returning to the Central Nursing Office in the Administrative Building as usual by way of the underground tunnels. I turned south into the last long section leading to the building housing the various offices. This is an extremely lonely area; out of sound or any kind of communication with others unless they happen to be using the same passageway. At that time of the night I would be the only one there. This was not unusual for me and thus not a frightening experience, although by habit I was alert to surroundings when alone in the tunnel. Tonight was as usual until I was about one-third of the way down that last length of complete loneliness. Suddenly, with no apparent reason, I felt that I should go no farther. This was such a strong impression that I turned around immediately and went back to a branching area of the tunnel and returned to the office by going outdoors . . . meantime chiding myself for having worked at the State Hospital "too long" and becoming too impressionistic. . . . I certainly had no plans to tell my strange experience to anyone!

At the office a patient was waiting for me to return with her to her own ward approachable by way of the tunnel extending beyond our building . . . or by a longer walk outdoors. Since she was not wearing a coat and it was cold outside I naturally turned toward the tunnel. She surprisingly stopped at once and said "I am not going in the tunnel." She would give no reason, only a flat refusal . . . so I offered her the use of my coat or sweater and we walked to her ward outdoors. A phone call . . . urgent . . . was awaiting me at the ward. A strange man had been apprehended in the tunnel . . . and male attendant nurses were trying to catch him. In the meantime he had escaped them by an unlocked tunnel window . . . ran to his car . . . and had driven away.

From the journal of Donna Garn Pillars, former assistant director of nursing,
Traverse City State Hospital, 1928–74.

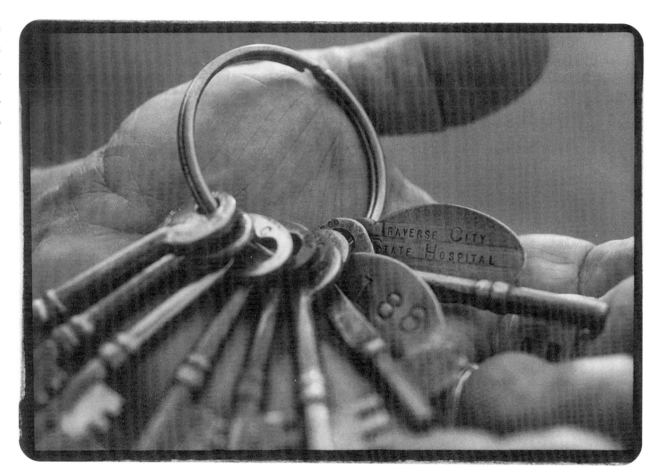

ORIGINAL BUILDING 50
KEYS WITH IDENTIFYING
EMPLOYEE NUMBER

Photograph by
Heidi Johnson, 2000

An Unlikely Hero

Henry was a nice patient. He was a big man, and although he could be a real corker sometimes, he had lived at the hospital for nearly thirty years and had become a big help to many of the nurses, including me. . . . One day in the summer, Henry had come over to help in our building. We had just cleared the ward— meaning we had taken everyone outside for recreation. Henry and I and some other nurses were outside with patients. After we counted [the patients], I realized we had missed one, so I had to go back on the ward to get him. The patient that stayed behind was known to be a real mean fellow, and although he used a cane to get around, he was very strong. I started looking for him on the empty ward, and when I entered one of the rooms, he surprised me from behind a door. When I tried to take him outside, he cornered me in one of the rooms. I was all alone on the ward, and there was no way I could have subdued him by myself. It all happened so fast, and the other staff had not yet realized I was gone. Meanwhile, the patient started swinging his cane at me, and I couldn't get out of the room. The only place I could hide from him was under the bed. So I scooted under there hoping he would calm down, but he didn't. He just kept on poking and swinging the cane at me as hard as he could, trying to hit me. Luckily, Henry started to miss me. Someone told him I had gone back on the ward to get patient so-and-so, and Henry seemed to know immediately that I was in trouble. Fortunately, I had not locked the ward door behind me, and Henry was able to get in. He distracted the patient long enough for me to get out from under the bed, and together we were able to grab him. Henry truly saved me that day

I can remember a few other times when we really had to trust our patients. Although strictly forbidden, there were many intense moments on the wards when we had to throw our keys to a patient and say, "Go get help," and they would do it every time. Since so many of us knew our patients so well, you usually knew who you could trust. Patients saved many an employee from harm or even death on those wards.

Recollection by Bonnie Witkop Hajek, former nurse attendant,
Traverse City State Hospital, 1965–89.

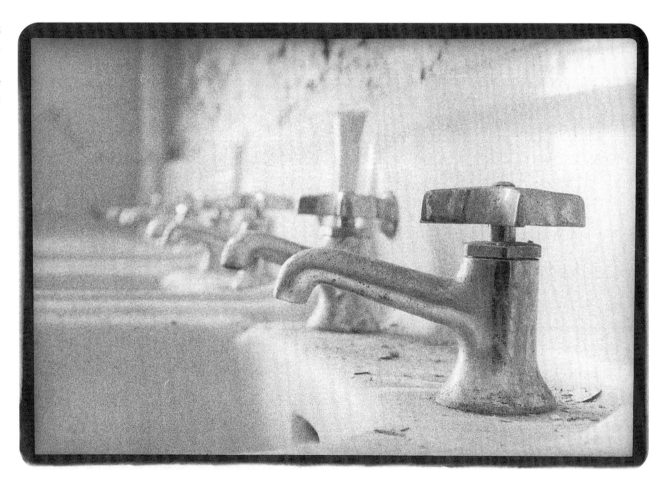

FAUCETS, WOMEN'S
BATHROOM, Cottage 25

Photograph by
Heidi Johnson, 1998

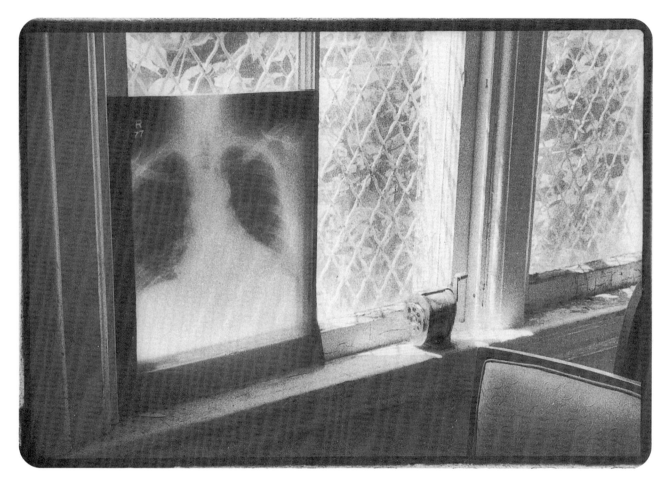

X-RAY IN WINDOW,
Cottage 25

Photograph by
Heidi Johnson, 1998

135

RESTRAINTS, Cottage 25. This type of restraint was rarely used on the wards of the Traverse City State Hospital. Although many patients were delivered to the hospital in these devices, nurses always removed any restraints before taking the patients onto a ward.

Photograph by Heidi Johnson, 1998

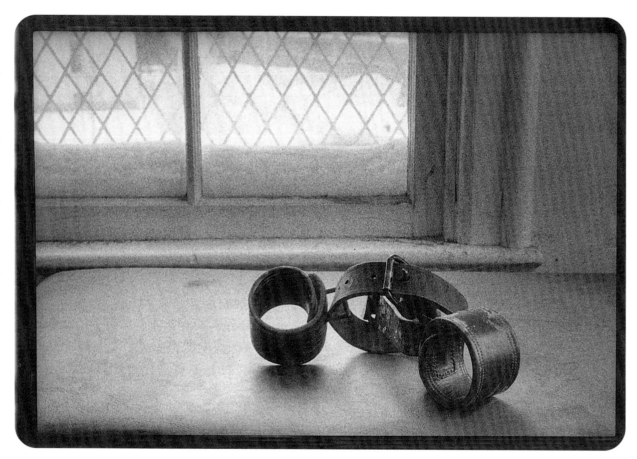

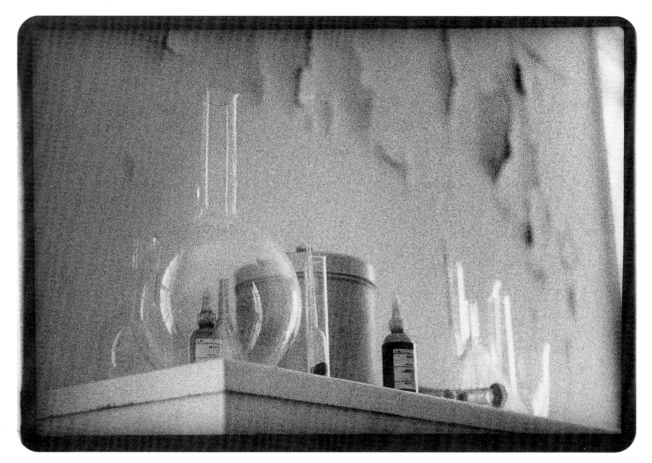

BEAKERS AND QUICKSILVER, stored in Cottage 25 prior to the state hospital liquidation sale of June 1998.

Photograph by Heidi Johnson, 1998

DENTAL CHAIR,
stored in Cottage 25
prior to the state
hospital liquidation sale
of June 1998.

Photograph by
Heidi Johnson, 1998

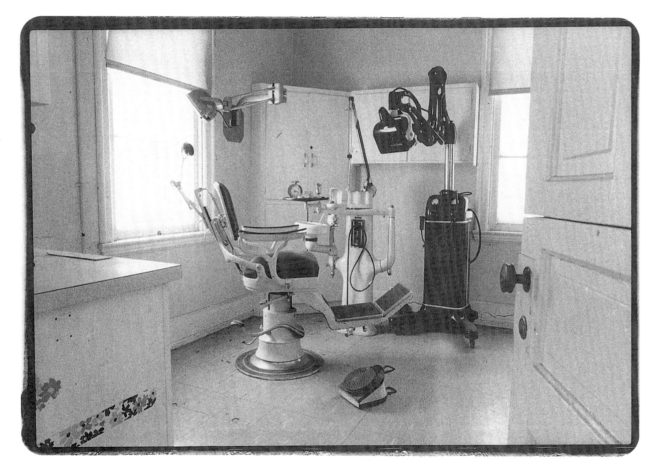

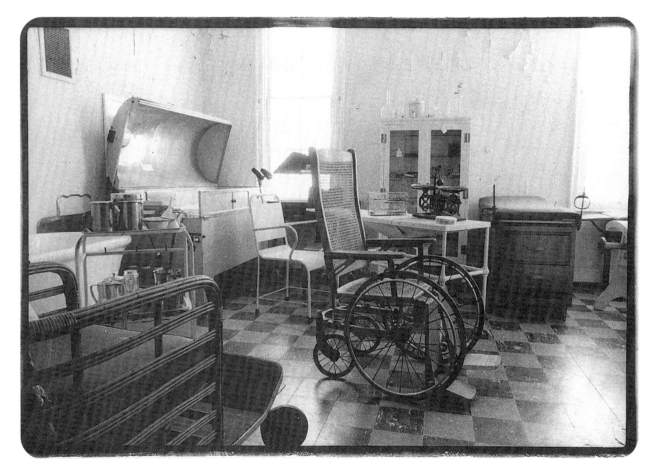

MEDICAL ANTIQUES, stored in Cottage 25. All items in this photograph were sold during the liquidation sale of June 1998.

Photograph by Heidi Johnson, 1998

WINTER SOLSTICE MOON
OVER MEN'S WARD,
Building 50

Photograph by
Heidi Johnson, 1999

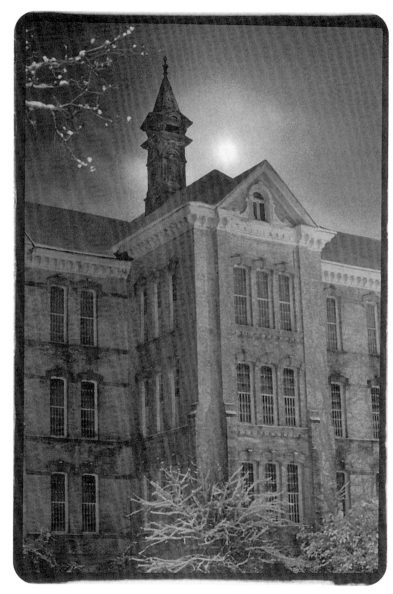

Evidence at Midnight

As I think of so many things that took place during the forty-three years of State Hospital experience it is difficult to determine which to record.

On one very large ward I had placed an extremely strict and very hard working supervisor. She was not of any easy-going, pleasing appearance, rather a large unsmiling, severe type of person to whom routine, procedure and discipline were of much importance. She had been given supervision over this building which was completely out of control with a number of employees quite determined not to cooperate in changing to give anything resembling adequate physical care to the patients there who were no longer able to speak for themselves. The assignment was hers because she seemed to be the only one with the courage and strength to win over almost insurmountable odds. She was good to her patients, insisted on good care and prompt attention but seldom wasted any show of affection on her working crew . . . and for some time they deserved none.

If there was a person on all of my night crew whom I would have thought to be atheistic or at least without respect for God . . . it would have been this woman. I liked her because she was doing the job for me that no one else could do . . . making a hospital unit out of a ward of extremely debilitated, incontinent patients, many of whom had developed large pressure sores. They were kept clean, cared for and the ward was no longer so offensive in odor that employees from other units begged not to be sent there to work . . . even for one night!

As in many long-term hospitals . . . this was the end of the road for many of the patients. Death was a frequent visitor. . . . It was on this ward, very late one evening, as I came in from making rounds throughout the hospital and walked down the hall that I observed a man in one of the side rooms very obviously dying. I had known this man for a long time. He was one of the most repulsive, deteriorated, untidy people on the ward. He was noisy and vulgar and profane. There seemed to be no good in him in any respect . . . but now life would be measured in a very few minutes.

Not wanting him to die alone, I stepped into his room and to his bedside without even calling the ward supervisor. She arrived almost immediately and stood at the foot of the bed. Three male attendants from the floor also walked in and stood by the bed. This was most unusual . . . almost like a planned meeting.

We had no more arrived when this man, upon whose face I had never seen an intelligent expression of any kind and whose eyes had glared only filth and hatred . . . looked upward with an expression of beautiful wonder and surprise and even radiance in that old repulsive visage. Only with his passing had we had a glimpse of the real person beyond the illness.

The "hard bitted" old supervisor, standing at the foot of his bed . . . before all of her ward personnel, declared in no uncertain terms, "There is nobody in all of this world that can tell me there is no God!"

That patient in the complete helplessness of the battle with his last enemy . . . probably gave the most convincing testimony of his whole life. I will never forget it!

From the journal of Donna Garn Pillars, former assistant director of nursing,
Traverse City State Hospital, 1928–74.

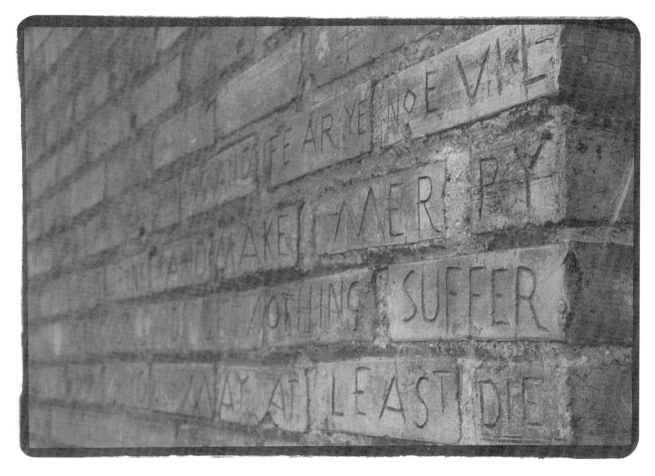

Exterior of hall 6,
men's ward,
Building 50,
circa 1929

Photograph by
Heidi Johnson, 1999

"*Make weary in well doing and fear ye no evil*
for God said eat, drink and make merry
and God said let nothing suffer
for tomorrow you may at least die."

ARCHITECTURAL DETAIL,
Building 50

Photograph by
Heidi Johnson, 1999

NORTHERN MICHIGAN ASYLUM CEMETERY PLOT, Oakwood Cemetery, Traverse City, Michigan, est. 1886. Between 1886 and 1940 more than 250 unclaimed deceased patients from the Northern Michigan Asylum were buried in unmarked graves at the Oakwood Cemetery in Traverse City. Of the 250 graves, only 3 have headstones.

Photograph by
Heidi Johnson, 1999

Men's clothing cubes,
hall 18, Building 50

Photograph by
Heidi Johnson, 1998

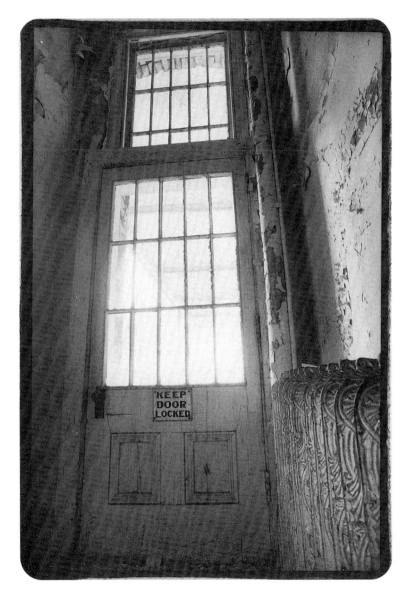

MEN'S WARD, entrance to porch

Photograph by
Heidi Johnson, 1999

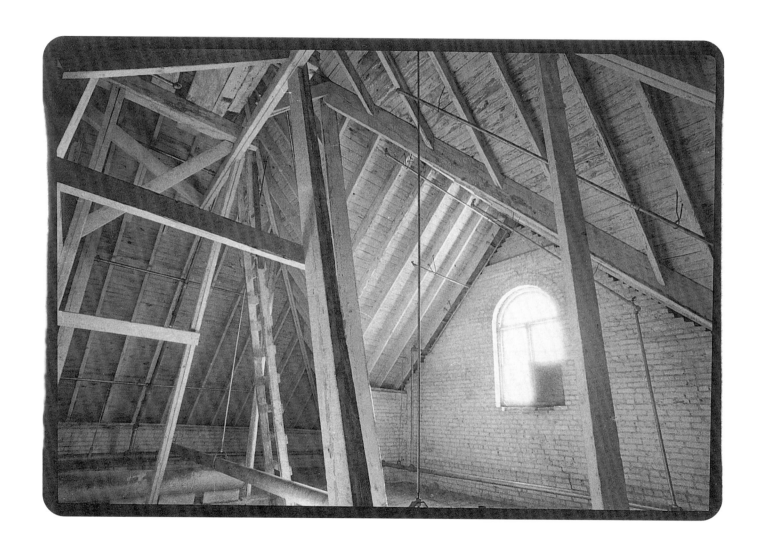

148

Attic Living

I do remember some things which took place in our living quarters which were lots of fun and most highly irregular . . . therefore top secret for many years! I was really sincere in being a good employee and also enjoyed my portion of humanity and its mischief along with all the others. At the time we were living in the large attic over one of the big buildings. One end of the attic contained two sleeping rooms, three beds, a short hallway and a very small bathroom. You reached these elegant quarters by way of an extremely narrow wooden stairway . . . up three flights of stairs. The fire hazard was extreme in this area. The building was very old, the partition between our living quarters and the other end of the long attic was made of wood and as dry as tinder. Rules were there could be no cooking appliances whatever. I don't think we were permitted a radio . . . and I'm not sure about table lights. Right now if I were to live up there I wouldn't want any of these because of the very real danger. At that time it didn't worry us much.

There were five of us living there . . . and as a rule we did not suffer from loneliness. Besides that, in our rooms we had all of the equipment we needed for cooking and serving complete dinners . . . doing this most secretly . . . and placing the largest oldest attendant in a chair with her back against the door during the partaking of the meal. She had some kind of a ridiculous foolish grace which she said so solemnly just before we ate . . . although it was sacrilegious . . . I wish I could remember it now. I think even God would see the humor in it!

Opposite Page:

ATTIC RAFTERS OVER MEN'S WARD 18, Building 50

Photograph by
Heidi Johnson, 1997

One day we almost blew our fun time . . . and possibly our jobs! One of the girls was popping popcorn in her electric corn popper. We heard the door open downstairs and assumed at once it was the assistant Director of nurses who would have sealed our doom and probably our last pay-check without mercy. The girl grabbed the still connected corn popper and shoved it under a bed. I forget who it was that came up . . . but it was surely someone not very observing. The smell of hot popcorn was all about the place . . . and besides that the popper under the bed kept on popping! That one almost got us!

From the journal of Donna Garn Pillars, former assistant director of nursing, Traverse City State Hospital, 1928–74.

Opposite Page:

Copper beech, planted circa 1915 on the grounds in front of Building 50, women's Cottages 23 and 25.

Photograph by Heidi Johnson, 1999

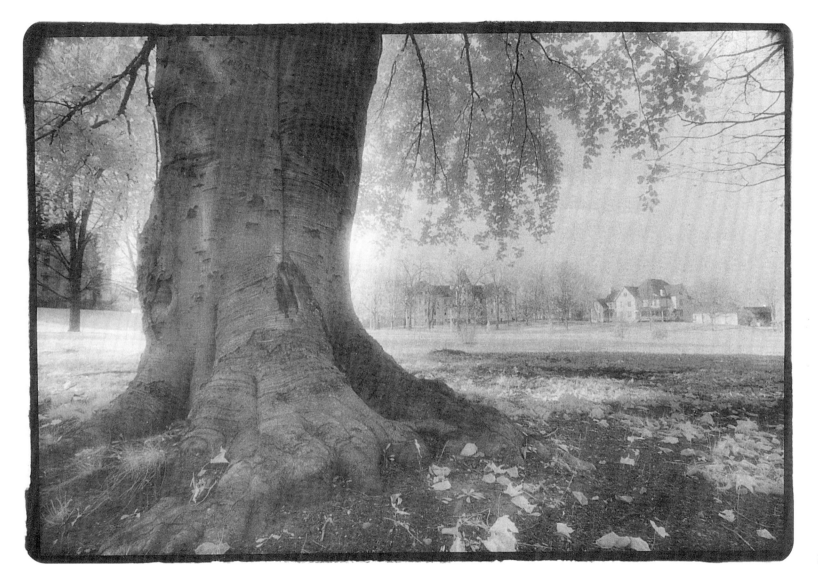

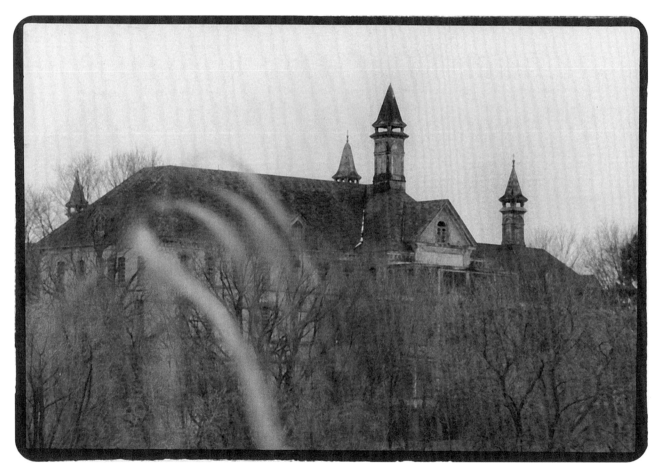

VIEW FROM WETLANDS,
men's wards
6, 12, and 18

Photograph by
Heidi Johnson, 1999

152

Bats

The other end of the attic was a lovely haven for bats and they accumulated there by the hundreds or more. Every once in a while the men would come in and kill as many as they could. This greatly disturbed this elderly attendant who roomed with us and if she knew they were coming she would go in and catch as many as possible and take them away. One day she had caught a whole pint of live bats and had them in a ventilated pint jar on her dresser. One of the girls who was deathly afraid of bats came in the door (she was also always hungry) . . . took one look at the jar and said, "Oh prunes!" . . . opened the jar only to see the prunes practically fill our small quarters. I doubt if she ever ate another prune! There were bats . . . everywhere!

From the journal of Donna Garn Pillars, former assistant director
of nursing, Traverse City State Hospital, 1928–74.

FIRE OVER MEN'S WARD, Building 50, October 25, 1948. This fire was started when a workman, repairing the roof, threw a cigarette butt into the ventilating spire. Over the years, large amounts of paper and debris had collected at the base of the air shafts from patients pushing material through the large grates located throughout Building 50. The cigarette ignited the debris, fortunately producing more smoke than fire. The large amounts of smoke baffled state hospital employees because the source of the fire could not be located. The fire was eventually extinguished, and no one was hurt. Immediately after this incident, every air shaft in Building 50 was thoroughly cleaned.

Courtesy of the
Grand Traverse Pioneer
and Historical Society

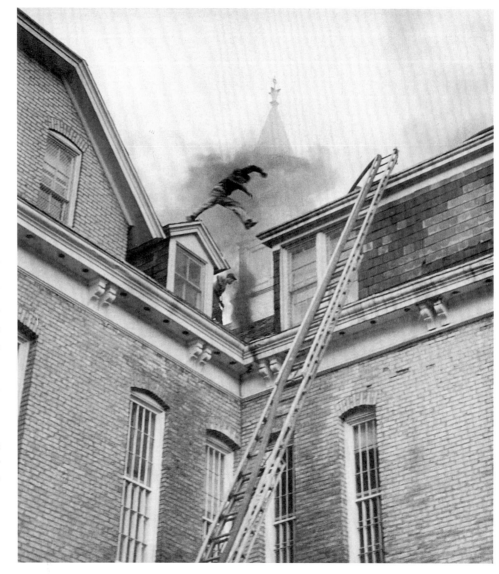

The Fire of 1948

One evening . . . maybe about six P.M. the fire alarm sounded. Now if there is anything that makes your hair stand on end . . . and sets the adrenalin racing through your system in a large State Hospital consisting of many very large old buildings . . . and containing hundreds of locked in people . . . it is the very first sound of the fire alarm!

Every person prepares for action . . . first . . . by determining by the counted sounds of the alarm just what unit and which ward is in trouble.

But "If the trumpet give forth an uncertain sound . . . who shall prepare himself for battle?"

That night something was wrong with the "trumpet." So I called the central telephone operator since she should have duplicate information coming in constantly on a special machine at her desk . . . but this was failing us!

Someone thought it was on Cottage 25 . . . and I ran approximately two blocks to that building only to learn that there was no fire there.

Fire trucks were on their way from the city . . . our own fire department was still in confusion. Then as I came out on the porch of 25, looking southeast I saw flames from the roof over the largest building of all . . . and in which the largest group of our patients were housed. This was farther away than my run to 25 . . . but by now the city fire trucks had been directed to the fire location and our fire department was also there . . . and things were beginning to shape up.

I went to the area. Patients were safely evacuated from the danger . . . but one thing remained with me. . . . Before those on the middle floor were moved, I, standing on the outside, saw many men at the windows. . . looking out . . . rightfully very concerned, calling out to ask about the fire . . . and to let us know that they were locked on the ward.

How many hospitals and nursing homes every year experience this very same thing . . . only to be unable to rescue the people?

Do they ever stop seeing those pleading ones at the windows . . . who finally die in the flames?

From the journal of Donna Garn Pillars, former assistant director of nursing, Traverse City State Hospital, 1928–74.

Opposite Page:

"ANGELS IN THE ARCHITECTURE,"
men's "most disturbed" wards
6, 12, and 18, Building 50

Photograph by
Heidi Johnson, 1997

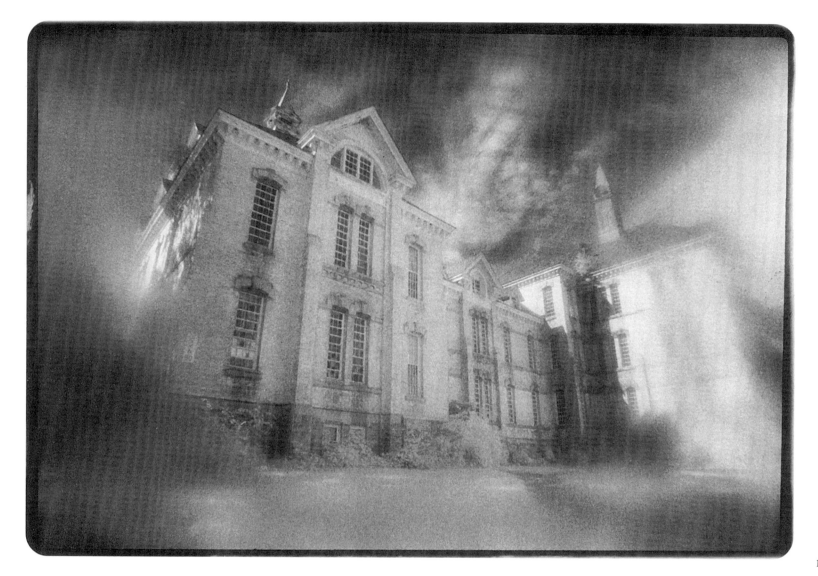

SPIRE AND BROKEN LAMP,
Building 50

Photograph by
Heidi Johnson, 1999

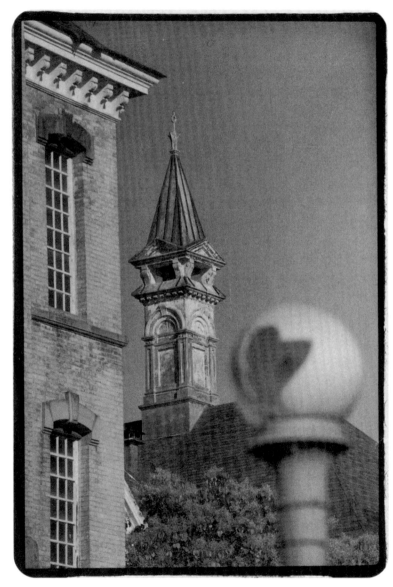

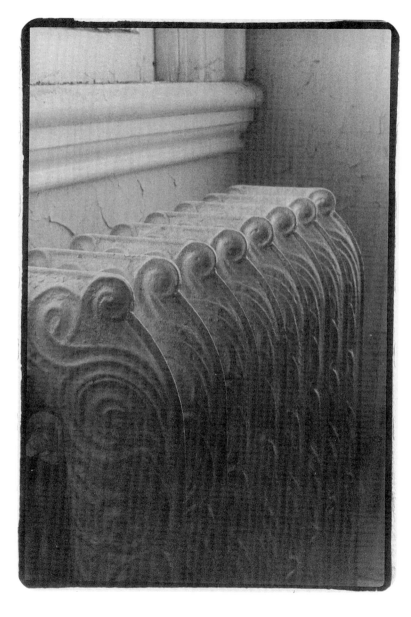

Radiator detail,
women's ward, Building 50

Photograph by
Heidi Johnson, 1997

HIDDEN PATH BEHIND BUILDING 50

Photograph by
Heidi Johnson, 1998

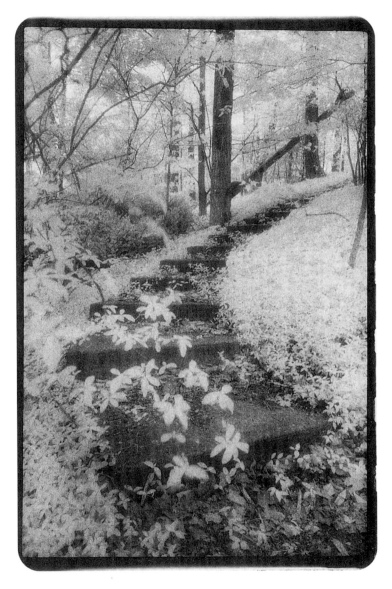

Sometimes when it was too much for me, I used to go away to a cluster of trees

behind Building 50. It was my place to escape, and no one would follow me there.

It was all mine, and no one could take that from me.

Elizabeth, former patient, interview, 1999

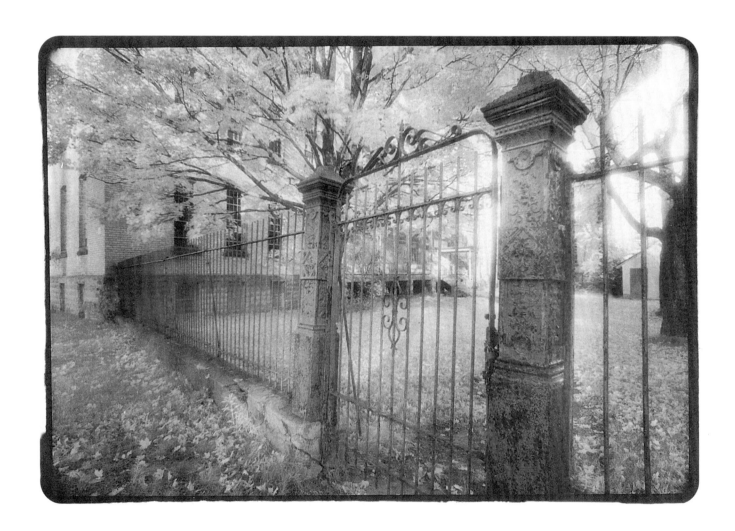

Ruby

So many of us cared, really cared about our patients and their lives. They were near and dear to our hearts, and although we tried not to take our work home with us, many of us did anyway. I remember one special little old lady named Ruby. She was just a tiny thing but very ill and very active. She was over seventy, but that didn't seem to slow her down one bit. She was all over the place all of the time. For some reason, Ruby took a liking to me right away. I never knew why, but she always called me "Addie." When I was away from the ward for a while or had a day off, I was told by the other nurses that she would lie on the floor and kick and scream, saying "I want Addie. . . .Where's my Addie?" But when I was around, she tried hard to be well behaved, and I in turn tried to spend time with her outdoors. She just loved to be outside. None of the other attendants wanted to take her out because she was such a handful. But I would say to her, "OK Ruby, I'm going to take you outside, but you have to hold on to my hand, and whatever you do, don't you let go of me cause I'll be scared and get lost." So Ruby would squeeze my hand tight and off we would go. I almost always took her to the same place—the gated area behind Building 50 and ward 5. Building 50 was closed by this time, and no one was there. It was a beautiful spot for Ruby and me. I had the key to the gate so I would let us both in and lock the gate behind us and then just allow her to run around all she wanted. She just loved that! Sometimes she would just sit on the grass in the sun, just

Opposite Page:

IRON GATE BEHIND WOMEN'S WARDS
5, 11, and 17, Building 50

Photograph by
Heidi Johnson, 1999

happy to be there. Other times she would run around and hide wherever she could. During these visits, I would sit on the steps nearby and do my ward paperwork so I wouldn't be "wasting time." Every five minutes or so I would hear this little voice from a hidden spot say "Aaaadieee," and I would answer back in a teeny voice, "I'm here."

On the day before she was transferred, I was asked to accompany her—to "deliver" her to another institution. I knew I couldn't betray the trust she had in me and was thankful on the morning she was transferred that I was scheduled for an afternoon shift. I never saw Ruby again, but even now there isn't a day that does go by that I don't wonder about her and pray that she found another Addie.

Recollection by Bonnie Witkop Hajek, former nurse attendant, Traverse City State Hospital, 1965–89.

Opposite Page:

SNEEZY AND EAGLE, paintings by
Virgil Hendges, men's ward,
hall 18, Building 50

Photograph by
Heidi Johnson, 1997

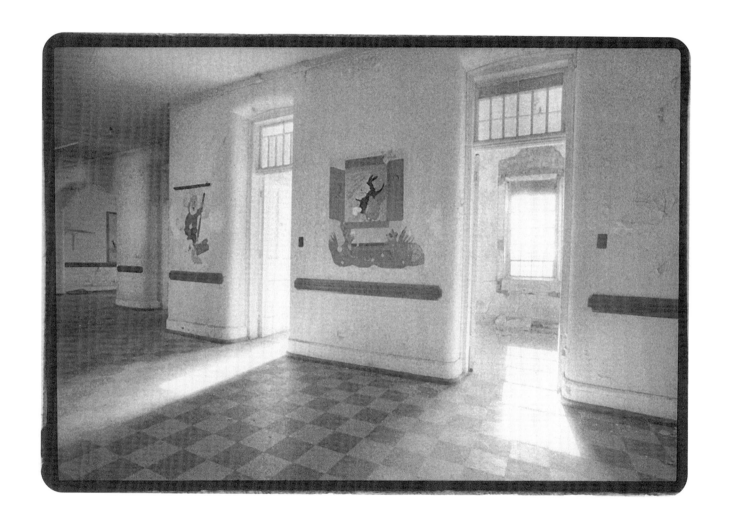

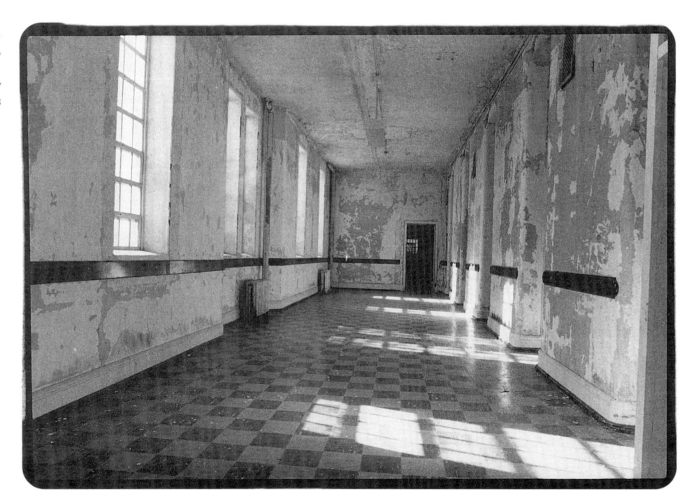

WOMEN'S WARD,
hall 5, Building 50

Photograph by
Heidi Johnson, 1998

Libbie and Hall 5

I mostly worked in the geriatric wards in Building 41, but there were times when I was sent to work on other wards in other buildings. One time I was told I was being sent over to hall 5 in Building 50, the ward for the most disturbed female patients. I was nineteen and pretty naive, and it didn't help that my coworkers had me half-scared out of my wits before I even left the building. But needless to say, I went over there, and, as I got closer to the door, I could hear the noise coming from the other side. It was very loud and I was terrified. But somehow I gathered up my courage and thought to myself, "Well, I'm just going to be brave. . . . I can do this. . . . I'm just going to walk in there and look brave, even if I'm not!" So I unlocked the door, opened it, and stepped in with confidence. I turned around to lock the door behind me and didn't even get all the way turned back around when all of a sudden this great big lady by the name of Libbie scooped me up and then proceeded to cradle me just like a little baby. I was so startled! I mean there I was in the arms of this person, and for the life of me, I didn't know what to do or say. I was very lightweight back then, and she started rocking me back and forth and said, "You know, I could just throw you right out the window right now." Well, without really thinking, I just grabbed the front of her dress and held on tight and said with as much bravado as I could muster, "Go ahead. I'm just gonna hang on, and you're gonna go right out the window with me." She looked down at me and started to laugh. When she put me down she was still chuckling, and I realized she had liked that I had stood up to her. From that moment on, Libbie followed me around the ward all day, protecting me from the rest of the patients. She even stood outside the bathroom door and waited for me. The other nurses thought it was so strangely funny, because they had worked with her for years and had never seen her react that way with anyone, let alone a total stranger.

Recollection by Bonnie Witkop Hajek, former nurse attendant,
Traverse City State Hospital, 1965–89.

"SEVEN DWARVES,"
painting by Virgil Hendges,
men's ward, hall 18,
Building 50. This painting lies
directly on plaster and cannot
be removed without consider-
able effort. Since this photo-
graph was made, vandals
have damaged it severely.

Photograph by
Heidi Johnson, 1997

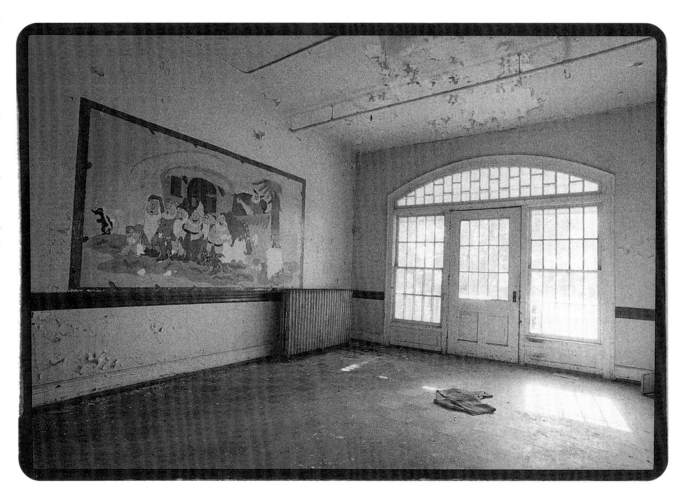

Virgil Hendges, 1919–1974

Virgil Hendges—boxer, gourmet cook, carpenter, ex–moonshine runner, artist, alcoholic, and father of seven—was admitted twice by court order to the Traverse City State Hospital in the 1960s, both times to "dry out." His daughter, Viann Hendges believes her father began to drink heavily as a young man, due to the stress of distributing moonshine during prohibition. In his mid-forties, Virgil was offered a job as a cartoonist for the Walt Disney Company in California. As Viann recalls, he reluctantly refused the position because he did not want to relocate his family or leave his mother, who was a long-term patient at the Traverse City State Hospital.

While at the asylum, Virgil had generous patient privileges, including access to the entire campus. He worked everyday on the hospital painting crew and he painted several images in Building 50 and in the surrounding cottages. Viann vividly remembers his painting "The Seven Dwarves." As a girl of six or seven, she would see it when she visited her dad in hall 18. In previous years, hall 18 had been used as a children's ward, but when she visited her father there, it was a ward for highly afflicted male patients. She recalls being terrified of the patients even though many did not notice her. Viann would always hide inside a large, empty cabinet in one of the dayrooms, crawling into one of its back corners.

For the rest of his life, Virgil would "partake" of alcohol, but he was never again admitted to the state hospital. In 1974 he died of heart failure at a family picnic. He was fifty-five years old.

PATIENT PAINTINGS BY
UNKNOWN ARTIST,
Cottage 25

Photograph by
Heidi Johnson, 1998

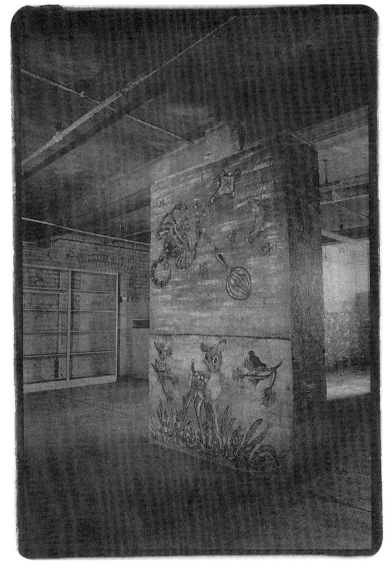

SPIRES IN FOG, Building 50

Photograph by
Heidi Johnson, 1999

WOMEN'S DAYROOM 1,
Building 50

Photograph by
Heidi Johnson, 1999

It was hell for me in 1975. I was alone, treated with no dignity and in despair.

One day I went into an empty dayroom. That is when I heard the tinkling of bells

and saw cherub angels in a citadel that seemed to be forming in the ceiling above me.

I knew then everything was going to be alright and no matter what was done to me,

I could go thru it.

Jo-Lynn, former patient, interview, 1999

Spires and gables,
Building 50

Photograph by
Heidi Johnson, 1997

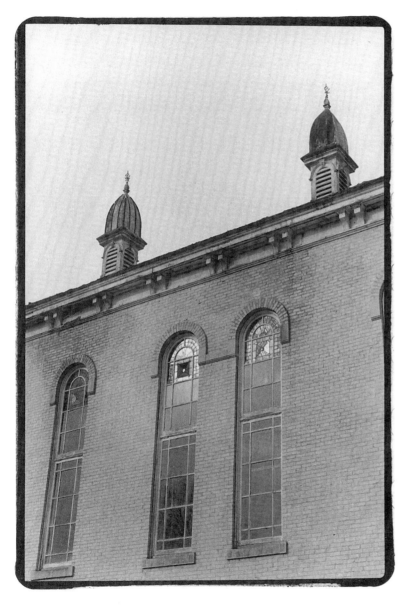

Exterior of original
patient chapel/library

Photograph by
Heidi Johnson, 1999

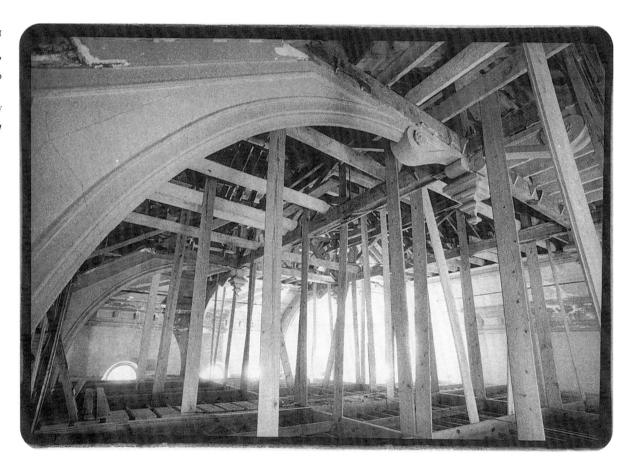

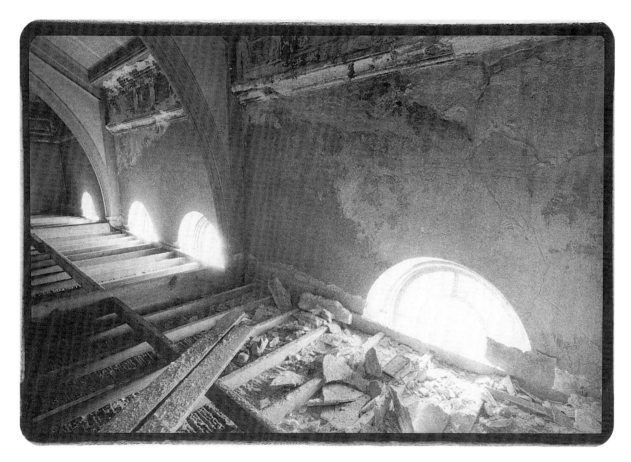

Chapel stained glass
above false ceiling,
Building 50

Photograph by
Heidi Johnson, 1997

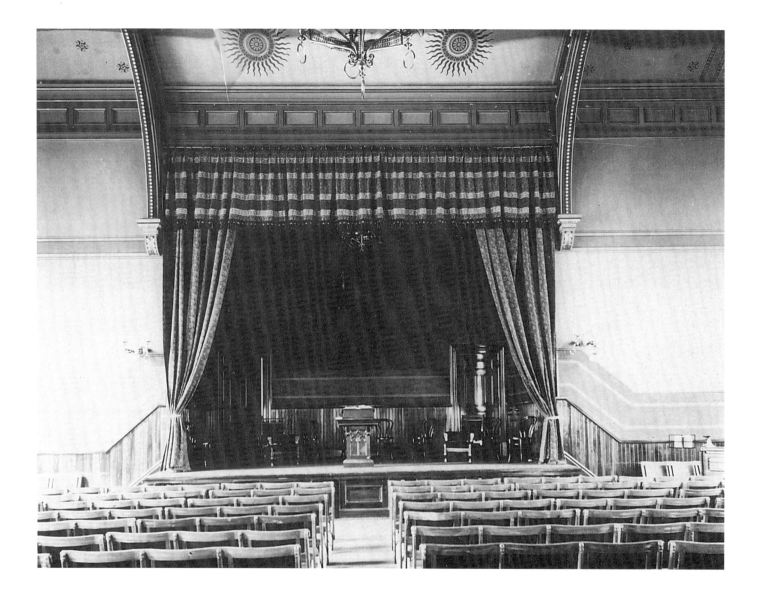

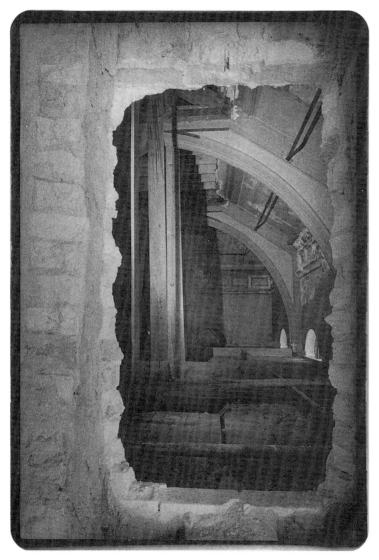

VIEW INTO SEALED AREA OVER FORMER PATIENT CHAPEL/LIBRARY

Photograph by Heidi Johnson, 1998

Opposite Page:

ORIGINAL ASYLUM CHAPEL, circa 1890. The Northern Michigan Asylum Chapel was constructed in 1885. The ceiling was painted less than a year later, after being badly stained by leaking water. Dr. Munson hired artist Frank W. Kiesele of Kalamazoo, Michigan, to paint a fresco across the entire ceiling. Kiesele was paid $225. From 1885 to 1920 the chapel was used not only during Sunday church services for patients and staff but also for patient dances, nursing graduation services, and Dr. Munson's large administrative meetings and formal dinners. Around 1925 church services were moved from this chapel into the much larger women's auditorium. The original chapel was closed and the deteriorating fresco ceiling eventually removed. Around 1930 the lower chapel was converted into the patient library. A drop ceiling was put in place, effectively hiding the original rafters from view. Workmen broke through a sealed attic wall to discover the original rafters around 1992.

Courtesy State Archives of Michigan

Oak bookcases
in former patient
library/original
chapel room

Photograph by
Heidi Johnson, 1997

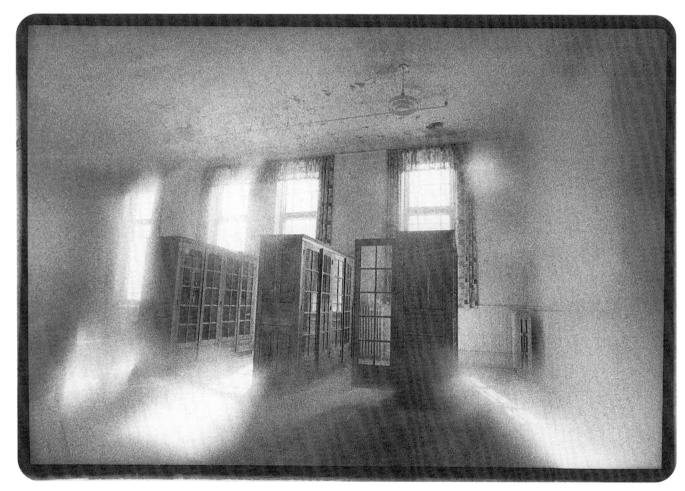

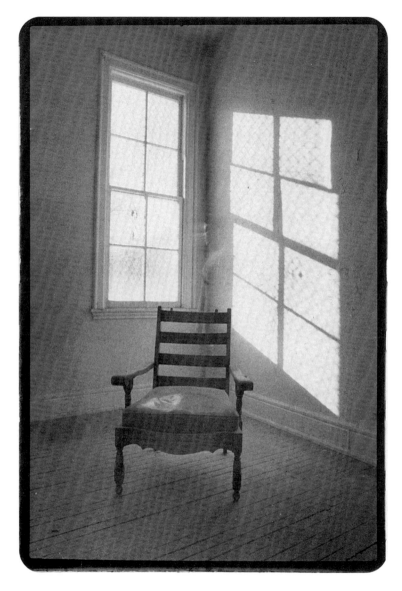

FIGURE STUDY 1, women's ward,
Building 50

Photograph by
Heidi Johnson, 1998

FIGURE STUDY 2,
women's ward,
Building 50

Photograph by
Heidi Johnson, 1998

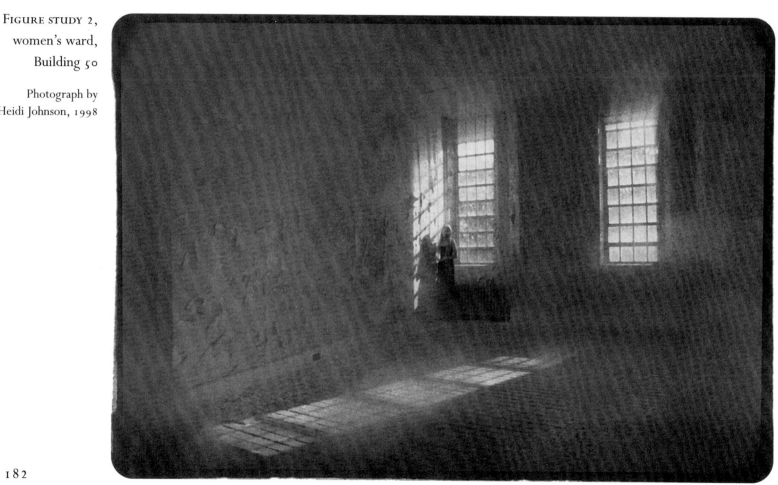

The Long Red Dress

There were so many strange events that occurred in the wards over the years, but one thing happened that I will never ever forget. On ward E2 in Building 35, there was a nurse named Margaret who had a very warm and good rapport with a patient named Becky. They got along tremendously well. Margaret just really liked this particular patient, and the patient just adored her. Becky was considered a model patient and never caused any trouble. When they put her to bed at night, she would stay there all night. She was quiet and reserved, and there was never anything particularly unusual about her behavior.

Margaret used to drive downstate on her off-weekends and would drive back in time to make it for her shift that started at 6:30 A.M. All of us nurses would meet before our shift and get ready for "report." Report was a routine meeting that all shifts conducted at the shift changeover. In our case we would talk with the night shift nurses about what had gone on in the ward since the day before. We were all taking off our coats and getting ready for our shift when Margaret started telling us about her drive home. She said,

———— ◆ ————

I had the weirdest thing happen to me this morning. I was driving along and I must have been dozing off, but all of a sudden, I saw Becky on the road. She was wearing a long red dress and was laying in the middle of the highway. I swerved to miss her and stopped the car. I got out, but she wasn't there. When I went to get back into the car, I realized that there was a sharp turn just ahead and, because I was dozing, I would have driven straight off the road and into a deep ditch. I just don't know what happened, but I do know that if I hadn't swerved to miss her or whatever it was that I saw, I know I would have been killed!

We all filed into the report room, and it was normally a very routine part of our day, but this morning, the head nurse of the ward began the meeting by saying "something was very wrong with Becky last night. She got out of her bed and was running all over the ward, and we couldn't catch her. She got into the clothes room and found a long red dress and put it on and kept running around. Every once in a while she would flop down on the floor and start screaming." Well, Margaret turned white, and we all sat there with our eyes as big as saucers and our mouths hanging open. There was no way this night nurse could have known what happened to Margaret on her way back to Traverse City. Margaret finally spoke and asked, "Did this all happen around 4 A.M.?" and the night nurse said, "Why yes, as a matter of fact, it did." With that, all of us turned white, and we just sat there without a word to say.

Recollection by Bonnie Witkop Hajek, former nurse attendant,
Traverse City State Hospital, 1965–89.

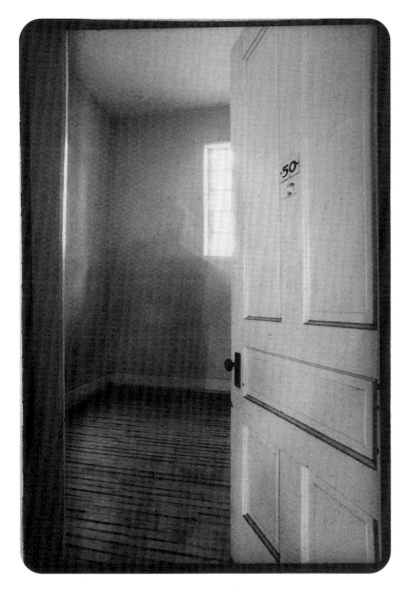

Figure study, room 50,
Building 50

Photograph by
Heidi Johnson, 1999

"Forever," patient painting,
basement of women's Cottage 25

Photograph by
Heidi Johnson, 1998

Remember

Each Book you Read

Each Thot you Think

Each Deed you do—is:

Henceforth Recorded

—Forever—

on the huge tape we call our

subconscious

Be ever so careful what you

Record

Afterword

It has been a profound and deeply rewarding experience for me to reveal at least a part of the powerful human history that still resonates within the walls of this asylum.

Remembering the era of the asylum leaves many of us with feelings of fear, sorrow, and regret. Some believe that by demolishing the remaining brick and mortar of these old asylums we will erase the past and no longer have to address the issue of mental illness or remember its troubled history. However, it is only through honoring the lives of former patients that we can hope to heal and learn from a century of medical history that inexorably entwined tremendous good with true human suffering. By looking at the painful truths of this era with empathy and understanding, we can begin to shatter the cruel stereotypes still associated with mental illness.

Thank you for joining me on this journey through the history of this rare place. I hope you connected to the angels of this asylum and that perhaps you were reminded of life's hardest lesson: compassion.

HEIDI JOHNSON

Sources

State of Michigan Reports

Reports deposited at Michigan Historical Center, State Archives of Michigan, Lansing.

Northern Asylum for the Insane. *Report of the Commissioners of the Northern Asylum for the Insane at Traverse City, Michigan.* Lansing, Mich.: W. S. George, 1882.

Northern Asylum for the Insane. *Report of the Commissioners of the Northern Asylum for the Insane at Traverse City, Michigan.* Lansing, Mich.: W. S. George, 1886.

Northern Michigan Asylum. *Report of the Board of Trustees of the Northern Michigan Asylum at Traverse City, Michigan.* Lansing, Mich.: Thorp and Godfrey, 1886.

Northern Michigan Asylum. *Report of the Board of Trustees of the Northern Michigan Asylum at Traverse City, Michigan.* Lansing, Mich.: Thorp and Godfrey, 1888.

Northern Michigan Asylum. *Report of the Board of Trustees of the Northern Michigan Asylum at Traverse City, Michigan.* Lansing, Mich.: Robert Smith, 1890.

Northern Michigan Asylum. *Report of the Board of Trustees of the Northern Michigan Asylum at Traverse City, Michigan.* Lansing, Mich.: Robert Smith, 1892.

Northern Michigan Asylum. *Report of the Board of Trustees of the Northern Michigan Asylum at Traverse City, Michigan.* Lansing, Mich.: Robert Smith, 1894.

Northern Michigan Asylum. *Report of the Board of Trustees of the Northern Michigan Asylum at Traverse City, Michigan.* Lansing, Mich.: Robert Smith, 1896.

Northern Michigan Asylum. *Report of the Board of Trustees of the Northern Michigan Asylum at Traverse City, Michigan.* Lansing, Mich.: Robert Smith, 1898.

Northern Michigan Asylum. *Report of the Board of Trustees of the Northern Michigan Asylum at Traverse City, Michigan.* Lansing, Mich.: Robert Smith, 1900.

Northern Michigan Asylum. *Report of the Board of Trustees of the Northern Michigan Asylum at Traverse City, Michigan.* Lansing, Mich.: Robert Smith, 1902.

Northern Michigan Asylum. *Report of the Board of Trustees of the Northern Michigan Asylum at Traverse City, Michigan.* Lansing, Mich.: Wynkoop Hallenbeck, 1904.

Northern Michigan Asylum. *Report of the Board of Trustees of the Northern Michigan Asylum at Traverse City, Michigan.* Lansing, Mich.: Wynkoop Hallenbeck, 1906.

Northern Michigan Asylum. *Report of the Board of Trustees of the Northern Michigan Asylum at Traverse City, Michigan.* Lansing, Mich.: Wynkoop Hallenbeck, 1908.

Northern Michigan Asylum. *Report of the Board of Trustees of the Northern Michigan Asylum at Traverse City, Michigan.* Lansing, Mich.: Wynkoop Hallenbeck Crawford, 1910.

Traverse City State Hospital. *Report of the Board of Trustees of the Traverse City State Hospital at Traverse City, Michigan.* Lansing, Mich., Wynkoop Hallenbeck Crawford, 1912.

Traverse City State Hospital. *Report of the Board of Trustees of the Traverse City State Hospital at Traverse City, Michigan.* Lansing, Mich.: Wynkoop Hallenbeck Crawford, 1914.

Traverse City State Hospital. *Report of the Board of Trustees of the Traverse City State Hospital at Traverse City, Michigan.* Fort Wayne, Ind.: Fort Wayne Printing, 1916.

Traverse City State Hospital. *Report of the Board of Trustees of the Traverse City State Hospital at Traverse City, Michigan.* Fort Wayne, Ind.: Fort Wayne Printing, 1918.

Oral Histories and Interviews

Pillars, Donna Garn, R.N. Journal entries and written recollections, ca. 1960–75. H. Johnson Collection. Traverse Area District Library, Traverse City, Michigan.

Sladek, Edward F., M.D. "Who Was Dr. Munson?" Transcript of a talk given to the medical staff of the Traverse City State Hospital, April 21, 1961. H. Johnson Collection. Traverse Area District Library, Traverse City, Michigan.

Garn, Ruth, Kermit Simon, Earle Steele, Margaret Sheets. "State Hospital Interviews," by Bill Jamerson, April–May 1992. Videotapes. Grand Traverse Pioneer and Historical Society, Traverse City, Michigan.

Steele, Earle, Bonnie Witkop Hajek. Interviews by author. Tape recordings. Traverse City, Michigan. 1998–2000.

Newspapers

Grand Traverse Herald, Traverse City, Michigan, 1883–1913
Morning Record, Traverse City, Michigan, 1897–1901
Evening Record, Traverse City, Michigan, 1901–11
Traverse City Record Eagle, Traverse City, Michigan, 1911–90

Books

Michigan Pioneer and Historical Society. *Collections and Researches Made by the Michigan Pioneer and Historical Society*. Vol. 13. Lansing: Darius D. Thorp, 1889.

Hurd, Henry ed. *The Institutional Care of the Insane in the United States and Canada*. Vol. 2. Baltimore, Md.: Johns Hopkins Press, 1916.

Burr, Colonel Bell, ed. *Medical History of Michigan*. Vol. 2. St. Paul, Minn.: Bruce Publishing, 1930.

De Kruif, Paul. *A Man against Insanity*. New York: Harcourt, Brace and Company, 1957.

Tomes, Nancy. *The Art of Asylum-Keeping: Thomas Story Kirkbride and the Institutional Origins of American Psychiatry*. Philadelphia: University of Pennsylvania Press, 1994.